William Wegman

William

PAINTINGS, DRAWINGS, PHOTOGRAPHS, VIDEOTAPES

Wegman

EDITED BY MARTIN KUNZ

ESSAYS BY

MARTIN KUNZ

ALAIN SAYAG

PETER SCHJELDAHL

PETER WEIERMAIR

INTERVIEW WITH WILLIAM WEGMAN

BY DAVID ROSS

HARRY N. ABRAMS, INC., NEW YORK

Editor (English-language edition): Eric Himmel
Designer: Tina Davis
Essays by Martin Kunz translated from the German by Catherine Schelbert
Essay by Alain Sayag translated from the French by Anthony Zielonka
Essay by Peter Weiermair translated from the German by Ivanka Roberts

Library of Congress Cataloging-in-Publication Data
Wegman, William, 1943–
William Wegman : paintings, drawings, photographs,
videotapes / essays by Martin Kunz . . . [et al.] ; interview with
William Wegman by David Ross.
p. cm.
Catalog of an exhibition held
May 5–June 17, 1990, at the KUNSTMUSEUM LUCERNE;
July 11–Aug. 26, 1990, at the INSTITUTE OF CONTEMPORARY ARTS, London;
Sept. 14–Nov. 5, 1990, at the STEDELIJK MUSEUM, Amsterdam;
Dec. 7, 1990–Feb. 3, 1991, at the FRANKFURTER KUNSTVEREIN;
Feb. 27–Apr. 7, 1991, at the CENTRE GEORGES POMPIDOU, Paris;
Aug. 11–Sept. 22, 1991, at the INSTITUTE OF CONTEMPORARY ART, Boston;
Nov. 8, 1991–Jan. 5, 1992, at the JOHN & MABLE RINGLING MUSEUM, Sarasota;
Jan. 23–Apr. 19, 1992, at the WHITNEY MUSEUM OF AMERICAN ART, New York.
Includes bibliographical references.
ISBN 0–8109–3951–7
1. Wegman, William—Exhibitions. I. Kunz, Martin. II. Ross,
David A., 1949– . III. Kunstmuseum Luzern. IV. Title.
N6537.W345A4 1990 700'.92—dc20 90–32650
ISBN 0-8109-2463-3 (pbk.) CIP

Contents

Acknowledgments

Surprisingly little of William Wegman's voluminous oeuvre has actually been published and seen. This book, and the related exhibition, combines examples of familiar works that are a must in any retrospective with many pieces that are making their debut here. Selected by Martin Kunz in collaboration with the artist, it attempts to present a comprehensive view of William Wegman's work that illuminates the development of Wegman's imagery within each of the diverse mediums he has explored as well as the underlying current common to them all.

A project of this nature requires the commitment and cooperation of many people. Lenders to the exhibition have permitted their often delicate works to tour for an extended period of time. We thank them all for their support. Wegman's assistants, Katleen Sterck and Andrea Beeman, and Teresa Schmittroth of the Holly Solomon Gallery in New York spent many hours documenting and photographing works. We extend our sincere gratitude to them, to curators and staff of the museums participating in the exhibition, and especially to Martin Kunz. Finally, William Wegman himself deserves a heartfelt "thank you" for his unflagging patience, his committed participation, and his generosity in accepting the ideas of others. The book is greatly enhanced and its authenticity underscored by his written contribution.

WIM BEEREN, DIRECTOR

STEDELIJK MUSEUM, AMSTERDAM

IWONA BLAZWICK, DIRECTOR

INSTITUTE OF CONTEMPORARY ARTS, LONDON

JEAN-HUBERT MARTIN, DIRECTOR

MUSEE NATIONAL D'ART MODERNE, PARIS

DOMINIQUE FRANÇOIS NAHAS, DIRECTOR

NEUBERGER MUSEUM, STATE UNIVERSITY OF NEW YORK AT PURCHASE

DAVID ROSS, DIRECTOR

INSTITUTE OF CONTEMPORARY ART, BOSTON

LAURENCE RUGGIERO, DIRECTOR

THE JOHN & MABLE RINGLING MUSEUM OF ART, SARASOTA

MARTIN SCHWANDER, DIRECTOR

KUNSTMUSEUM, LUCERNE

PETER WEIERMAIR, DIRECTOR

FRANKFURTER KUNSTVEREIN

Introduction

The large-format (24 × 20″) Polaroids and other photographs in which William Wegman enacted "living pictures" with his dog Man Ray have become world famous. William Wegman and Man Ray, who died in 1982, are in fact indelibly associated with each other in the public eye, thanks to these photographs. Less well known but equally important to his art are his brief videotaped stories starring Man Ray and the artist. Entertaining and even comic but no less serious in their artistry, Wegman's productions stood out against the early works of video art by others, which were characterized by an esthetic of consciously extended duration and artificially constructed boredom. The open and yet subtle humor of Wegman's photographs and videotapes is often based on ordinary, even mundane situations. It is a humor frequently concealed or implied in visual riddles, in which word and image stimulate or occasionally neutralize each other but always with a playfully entertaining flair. Wegman's sense of humor lends his work an iridescence. But were it not for his star model, Man Ray, and recently, after a break of a few years, Fay Ray, who give his enigmatic art such a palpable and comprehensible appearance, Wegman's imagery would be accessible only to a very small public.

Wegman's subject matter in photography and video covers a relatively small range. In other media such as drawing, practiced with great regularity since 1972, and painting, taken up in 1985, Wegman's subject matter acquires encyclopedic proportions; it embraces the sum of all knowledge, albeit of a trivial nature, as in the simplistic classifications of knowledge and facts used in school books.

Wegman uses his mediums to express his deep familiarity with the nuances of popular culture in America, whose mass media perpetuate art forms that are far more conventional and trivial than those of contemporary high art, although high art in America is very much enriched if not nourished by mass culture and civilization. Toying with trivial forms is an intellectual pastime whose fascination grows in direct proportion to its ambivalence regarding these forms. Wegman's art is buoyed by such ambivalence. The sophisticated, entertaining tension in his work arises out of a contrast of trivial, even mannered, ideas with a spirit of tomfoolery and utter absurdity; ciphers, images, scenes have been taken out of their quotidian context and, divested of artistic intent, seem almost a Duchampian mockery of art per se.

Wegman often takes an anticyclical approach to contemporary trends and current pictorial norms. At a time when exponents of Body Art, Conceptual Art, and Arte Povera were transforming their ideas into installations and live performances with audiences, Wegman used photography as the vehicle for his ideas and their materialization and contented himself with staging productions for the camera alone. Out of step with the revival of painting among younger artists after 1980, Wegman did not take to the paintbrush until well into the decade, when the fashion for painting was already on the decline again. He had no qualms about being considered behind the times. An absurd assessment, anyway, considering the originality of his pictures. Unlike other contemporary artists who, following the successes of American painting in the 1950s, work in large formats, Wegman favors small formats in all of his mediums. He loves small drawings and 8 × 10″ or 11 × 14″ photographic prints. Even his 24 × 20″ Polaroids are small in relation to the formats in currency today. Both these and his paintings are intended for private use. Wegman's preference for working in intimate, modest

dimensions underscores the human scale of his art. Many of his works may be read as "tele-images"; the TV screen transmits the same intimately scaled pictures gleaned from the "global village" of the great, wide world into the privacy of living rooms the world over.

The form is private and intimate, but the content is the image of the world that is conveyed by mass culture and has become the substance of our civilization today. Ambiguity marks Wegman's pictures. It is difficult to pin him down to an esthetic attitude, a style. He conceals himself behind humorous, witty, ironic, cynical disguises. He eludes clearly defined positions by making fun, by mocking himself, and even indulging in conscious banality. He subverts the—sometimes deadly—seriousness of the avant-garde. He retreats into the almost entirely hermeneutic pictorial riddles of his pictures, in which logical trains of thought are forever being uncoupled. That is, in fact, the only way to decode them. Decoding Wegman's imagery, his pictorial riddles, and adequately presenting the artist and his oeuvre—these are the issues we have tried to deal with in the present exhibition and publication.

Some of Wegman's pictures, popularized through publication in major journals and mass magazines, are certainly more famous than the artist's name. Wegman's art as a whole is not well known. Two retrospectives, the first in 1979/80, the second in 1982, toured the United States. Wegman's first dog, Man Ray, was still alive at the time and Wegman had not begun to paint, which has become an increasingly absorbing concern for him since 1985. The second exhibition and catalogue were titled "Wegman's World." Today the title of a publication such as the present one would have to be "The Worlds of Wegman's World."

These "worlds," all of which ultimately unite to form one worldview, are prosaically broken down, in the present exhibition and catalogue, into the mediums of photography, video, drawing, and painting, four worlds which are in turn subdivided to reflect the chronological evolution of each medium. Thus, the chapter on photography has sections on black-and-white work, the Polaroids of Man Ray, and the Polaroids of Fay Ray, in that order. Wegman naturally works in more than one medium at once so that his output runs parallel, although with sporadic shifts in focus from one medium to another.

An exhibition that embraces all of Wegman's mediums obviously cannot present a complete retrospective of each one. Key works have been selected in each area with a view to their significance in terms of chronology or type. An exhibition of this kind supplies the basis for decoding Wegman's worlds and ultimately his own world as well. Writers, most of whom had worked on and were familiar with the concept of the exhibition, were invited to discuss the artist's work in various mediums, in an attempt to convey at least some of Wegman's prismatic personality. As editor and writer, I soon realized how delicate the undertaking was. A first stage of analysis served only to underscore Wegman's elusive, enigmatic iridescence; he is like a fata morgana, always vanishing, always just out of reach.

Wegman toys with the viewer like Punch with his audience. One moment he may be seen peeking between the curtains in his theater of images; the next he may be peering out over the prompt box ready to take us backstage to explain his pictures, his ideas. Only then do we discover that he makes no secret, in his pictures, of the sources of his imagery. They are obvious

because they are so popular: illustrated primers of the 1950s, grade-school readers, and picture encyclopedias, for instance. Wegman himself, however, refuses to be pinned down. There is no fragmented quotation that might be pieced together from clues in his work. His image is captured in a magic lantern that can discover shades of reality in the dark but cannot record them. Background, profile, contours of a figure can be discerned, but the disenchantment is never complete. Punch, our guide, leaves us the impression of a highly expressive mime, a comedian, a slapstick artist, who amuses us, makes us laugh, and on occasion angers us by tripping us up with his nonsense. Yet only then do we discover that there is sense to nonsense.

In spite of the laughter and comedy in Wegman's work, it confronts us with the tragic, isolated LOOK of the loner, the quintessential artist. Witness the representation of the eyes throughout Wegman's work. The eyes of Man Ray and Fay Ray are of an irresistible eloquence. They have the LOOK of the melancholy clown whose antics can never quite hide the sadness in his eyes. William Wegman belies himself in his altered photographs, for instance, when he draws circles around his eyes as if to put on his own look, like a pair of glasses. Like any clown, William Wegman makes us laugh and enters our hearts while never quite allowing us to penetrate his own spiritual and mental depths. We can only sense his depths as we sense, but never know, the depths of an ocean.

This publication hopes to give the viewer and reader at least a glimpse, a taste of the enigmatic, fascinating, iridescent personality and world of William Wegman. Powerful pictures can never be entirely decoded, but therein lies their strength; they always speak for themselves.

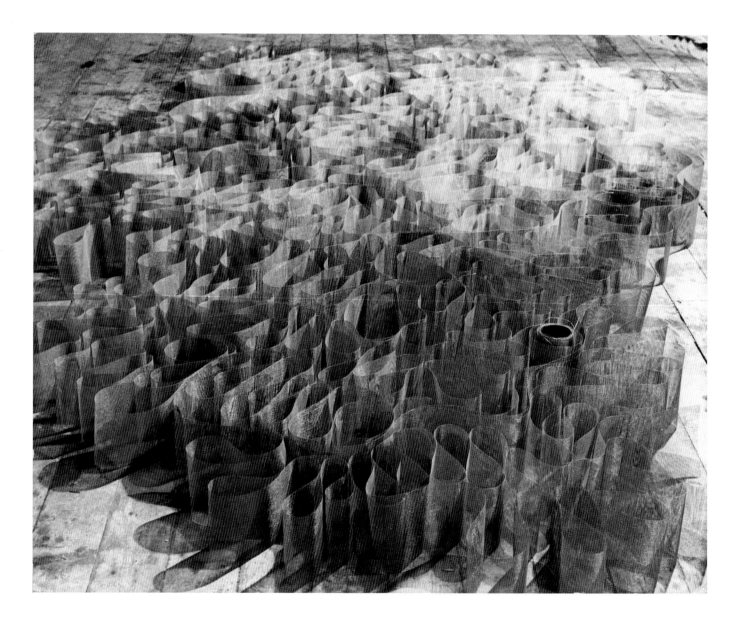

UNTITLED (ROLLS). Installation at the Detroit Institute of Arts, October 5–19, 1969. Fiberglass screen

An Interview with William Wegman

DAVID ROSS: You're originally from California?

WILLIAM WEGMAN: I was born on a tiny cot in southwestern Massachusetts during World War II. A sickly child, I turned to photography to overcome my loneliness and isolation.

ROSS: I knew that. There is a sense of pathos in your work, of being an artist dealing with inevitable failure and having to overcome incredible adversity. There is something Horatio Algeresque about it all. You as the American artist using your art against all the torments and assaults of modern life.

WEGMAN: Really, that's ironic.

ROSS: I guess irony is the right word for it.

WEGMAN: Pathetic irony.

ROSS: What I mean is that there is an inherent tension in the humor that comes from what you missed while the ostensible event was taking place.

WEGMAN: Sometimes it's a reaction against my own posturing. As a student I was a "blender" artist.

ROSS: Blender?

WEGMAN: My big idea was to combine the hard edge of Suprematism and De Stijl with the drips of Abstract Expressionism.

ROSS: Sort of like the "edge" of earlier abstraction meets the gutsy immediacy of Abstract Expressionism.

WEGMAN: The best of both. A bouquet. I eventually purged the personal and the sentimental to arrive at pure and simple geometric abstraction. Later in three dimensions. My little twist was that it glowed in the dark.

ROSS: Sounds scary.

WEGMAN: My last painting during this period in my life was in 1966 as a grad student at the University of Illinois at Champaign. A $4 \times 8'$ Donald Judd-like construction. Sadly, I gave it up.

ROSS: Sad because you realized it had been done before or sad because you thought you couldn't do it?

WEGMAN: More because I felt it didn't belong to me and that I could become an average good painter following that direction, but not an average great painter. I guess I felt that painting didn't belong to me.

ROSS: But this was all part of a larger generational shift as well. Your friends, your artist peers were also making a similar somewhat depressing realization about their own potential in regard to the weighty accomplishments of the older generation.

WEGMAN: Of Modernism?

ROSS: Yes, of Modernism and what was left for them in terms of a slice of this heroic pie. The idea of being an artist-hero was a romantic fiction in the late '60s. In the late '60s all we needed to be was . . .

WEGMAN: Part of the solution. Not part of the problem. Well, . . . I knew it was my problem. I didn't think it was anyone else's though.

ROSS: Does it seem strange to be painting again?

WEGMAN: Funny, strange, and eerie.

ROSS: What made you start again?

WEGMAN: I had the urge to. . . . An increasingly uncontrollable urge. Is that wrong?

ROSS: No. Do you feel guilty about it?

WEGMAN: I had deep reservations.

ROSS: Were you afraid of what they might say?

WEGMAN: Painting is dead, after all. It's a little anticlimactic.

ROSS: Do you mean, following the line of your other work,

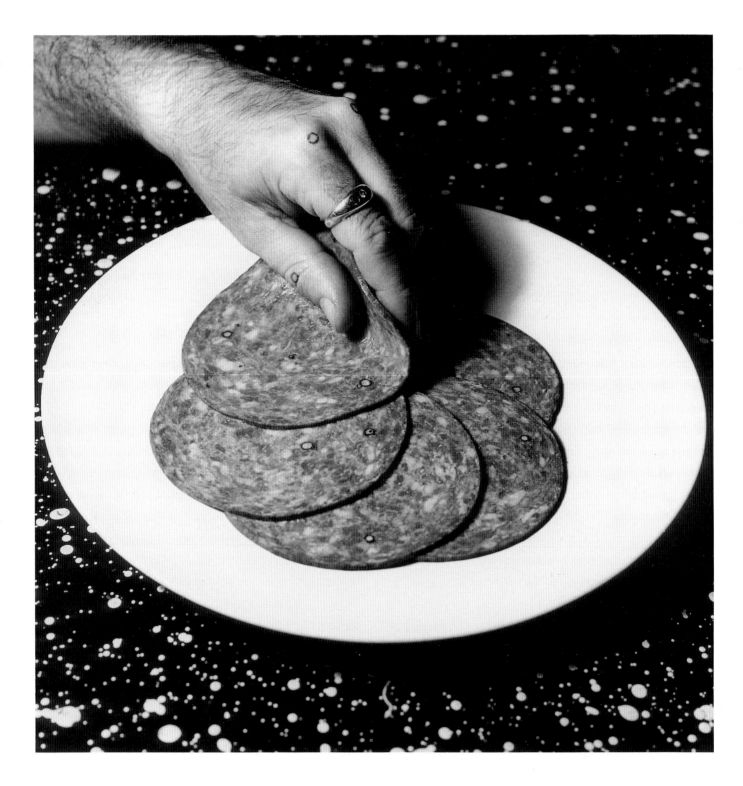

COTTO. 1970. Photograph

it doesn't follow?

WEGMAN: At night, before going to sleep, I would have these visions. In this dreamy state, the Lord told me to start using my God-given talents. I interpreted this to mean painting.

ROSS: Very well. But does this mean God isn't interested in photography?

WEGMAN: God knows I'm still involved. When I first started making photo pieces it wasn't with the idea of a commitment to the medium. I didn't think I would have to become a photographer to make my photographs. I recall that anything could be used as material for art in that era. Photography was just one more thing.

ROSS: Talk a little about that time. Did you have a sense of disengagement with what you saw around you as a young artist? Did you have sense of an audience for your work?

WEGMAN: I was in Wisconsin teaching sculpture—which was for me anything done in space and time. For instance, I was throwing radios off of buildings and photographing them . . . just to have a record of it. So I could show someone else.

ROSS: Who?

WEGMAN: Important people. This was the era of the piece movement . . . outdoor pieces and indoor pieces—floor pieces. I was working on a wall piece. I remember John Chamberlain came into my studio. He was a visiting artist. Some stuff I had stuck to the wall had fallen down. I was working with mud and photographs and thread, eyelashes, carrots, and acetone.

ROSS: Yum.

WEGMAN: He thought it looked great. It was a big mess. I knew what he meant though, but for me I needed some more clarity of intent. A way to start and finish a work and this was all middle.

ROSS: To enclose it.

WEGMAN: Yes. I needed that in order to proceed from one piece to the next. I had to get it myself. I felt lost. Then I had a "Eureka" type experience. Both video and photography contributed to that moment. I remember one photo in particular—COTTO [1970]. I had drawn little rings—little circles on my left hand on my fingers with my ring on my index finger and I went to a party.

ROSS: Very '60s.

WEGMAN: Well, a plate of salami was on the table and reaching in I was struck by the peculiar relationship of these little rings with the little rings in the salami—the peppercorns. Anyway I rushed home with the salami, set up my camera and photographed it with my own hand reaching in. I developed the negative and printed it and . . . "Eureka."

ROSS: And?

WEGMAN: Meaning I could construct a picture and that way directly produce a work—not a secondary record of it. The "construction" existed only for that purpose.

ROSS: Could you elaborate?

WEGMAN: Well . . . previously, my use of photography was to document an installation or event. The problem was to find a vantage point to make the piece look good. I remember floating Styrofoam commas down the Milwaukee River. I had to rush up the bank and quickly set up the camera on the bridge to catch them floating by. This new realization allowed me to set up things just for the camera in the comfort of my own studio.

ROSS: You then started producing these contained moments

STYROFOAM CHAIN (250 '), Milwaukee River, May 1969

for the video camera? Did you feel your work fit into the whole video revolution you found taking place around you, or was it more of an extension of your "fabricate to photograph" attitude towards photography?

WEGMAN: I wasn't really around during this revolution. I later met Nam June Paik and Bruce Nauman, who I think of reverently. Actually, I thought my work was about as different from other video makers as you can get. The only common denominator was the medium.

ROSS: You seemed to be working yourself out of a corner, and yet you introduced an important element into the fledgling video community. Your works were short and, because they were often absurd, they were accessible. They seemed to use conventions from real TV—the blackout sketch of Sid Caesar—yet subvert them by insisting upon a rather hermetic "insider" anti-humor. You know, like "no soap radio" kind of jokes.

WEGMAN: They were linear in opposition to the "field" approach that was in at the time. For me I needed an entrance and an exit. Some artists just used the whole reel. For me they were a solution to a unique communication problem. How to reach an audience. They could be broadcast or shown closed circuit.

ROSS: You have often described your whole career in terms of technical milestones and hardware achievements.

WEGMAN: My first deck. The first that I owned was a CV Sony with a surveillance type camera which was very wide angle. Within these strict limitations I produced Reel 1. By Reel 2, I owned a Sony AV3400—another table model. I never liked porta-paks. I increased my space by 12′ with the RE15 electronic microphone, sound was more understandable and I began speaking more. By 1975, I owned a

color VHS recorder and camera. With each replacement new possibilities were opened but others were shut down. I think I'm a very tech sensitive artist in that I don't overreach the media. In fact, I revel in the limits. With color and higher resolution I found it hard not to look like low-budget imitation Saturday Night Live stuff. You know, bad network television.

ROSS: Yeah, I think I follow you. But it is far more important that you were among the first to recognize that video was more a function of drawing rather than of cinema or television.

WEGMAN: I am attentive to the closed mirrorlike nature of video . . . the almost mesmerizing effect of the image in the monitor in relation to the subject which . . .

ROSS: Which was you . . .

WEGMAN: . . . and Man Ray . . .

ROSS: . . . and your lucky T-shirt?

WEGMAN: T-shirt?

ROSS: I swear that hardly a week that goes by that I do not think of that video piece where you find the shrunken lucky T-shirt at the laundromat.

WEGMAN: Oh. That was lucky.

ROSS: I'm sure it was. Maybe I relate to that piece because everyone thinks I'm lucky too.

WEGMAN: Talk about lucky, I own my own laundry machine now and I don't have to go to the laundromat anymore. I can put the dryer on high and make my own lucky T-shirt.

ROSS: You could have your own line of pre-shrunk lucky T-shirts. What about a line of talking fish?

WEGMAN: Speaking five languages and wearing wet T-shirts.

LUCKY T-SHIRT, videotape from Reel 2 (1972)

ROSS: And gasping for water.

WEGMAN: Or something.

ROSS: There seems to be a struggle in your work—in all of your work, but it's most obvious in the video and the drawings—you seem to be trying to come to grips with a world that doesn't work. It disturbs me that critics have often seen your work as simply humorous and benign. I don't think your art is all that genteel. It's occurred to me that you are dealing with a deep sense of loss and anxiety . . . concern about the end of world. I see it as very troubled art. In fact I have often found something deeply ominous about your art. By the way, is Wegman a Jewish name?

WEGMAN: I once knew a young boy who had a gravel driveway. The little boy loved the driveway. He liked to play with the little pebbles. He had to go to the hospital for an operation. When he came back home he found the driveway had been paved.

ROSS: Is that true?

[pause]

ROSS: The formal devices you were exploring in video have an analogue in literary criticism and in literature itself. What authors have influenced you?

WEGMAN: Beside Borges and Tolstoy? Proust.

ROSS: What about Buster Keaton?

WEGMAN: In California I liked the late night lumberyard ads and used car ads that spun off from Bob and Ray. I love Bob and Ray.

ROSS: And Man Ray. Having been a selfconscious student and then a somewhat reluctant teacher/grad student seems to have made a strong impression on you. . . . You seem to have remained obsessed with the role of the academic, the explainer . . . that comes across for me in one particular video with Man Ray.

WEGMAN: Well, yes, in SPELLING LESSON [1973–74] and in many of the black-and-white photos of the early 1970s as well. Education is the subject of countless drawings. Grad school was torture for me. I don't know why. Video is great for teaching, however. You can improve your golf swing or practice your bedside manner. You are going to die a slow and painful death. When I was teaching at Cal State Long Beach in 1970, I borrowed equipment from Physical Education and Psychiatry.

ROSS: Is that how you overcame your "rage and depression"?

WEGMAN: I believe that was through speed reading and the megadose prescription of deodorant. Having a dog helped.

ROSS: What about Man Ray? Your work with him is extraordinarily sought after, perhaps eclipsing your other work in terms of popular recognition.

WEGMAN: Again, I was incredibly lucky (not apparently lucky) in getting Ray and I think this is significant.* Getting him at just the right time—just when my video and photo work was still new and exciting to me. Ray fit right in. He was really curious about it and became very serious about our work.

*Man Ray was born in Long Beach, California, in July 1970. My wife Gayle and I bought him for $35. I wish I could remember the name of the family because I would like to thank them and perhaps give them more money (not really). He loved games and he absolutely knew about the camera. It is interesting to note that although I used him in only about 10 percent of the photographs and videotapes, most people think of him as omnipresent in my work. It irked me sometimes to be known only as the guy with the dog, but on the other hand it was a thrill to have a famous dog. —W.W.

OPENING. c. 1973. Pencil on paper, $8^1/_2 \times 11''$

ROSS: But does it bother you that in many circles you are known as the guy with the dog?

WEGMAN: First tell me what you think of my drawings. But seriously, I'm grateful for the recognition. It's frightening to think of what I would have done without him.

ROSS: It clearly has made you and that work of yours a household word,—at least in the houses of dog lovers.

WEGMAN: Especially those without yards.

ROSS: Pathetic!

WEGMAN: For me, Ray started as a space modulator, then became a kind of narrative device, then a character actor and ultimately a Roman coin.

ROSS: Julius Caesar?

WEGMAN: Or JFK.

ROSS: To me, your use of a contained vocabulary of formal elements (even though they didn't behave formally) has always been central to your work. This is especially evident in the drawings, which continue to serve as the core of your work. I mean, the drawings most elegantly represent your desire to present "contained" ideas as objects . . . to question the role of language (visual and verbal).

WEGMAN: ?

ROSS: Also, the drawings were so spare, not really minimal, but definitely associated with a reductive approach to the notion of presentation.

WEGMAN: For one thing, I really was relieved not to have to drag something in front of the camera. I could use a pencil and paper. A regular pencil and typing paper. That appealed to me.

ROSS: I remember the first time I saw them exhibited, the room looked so beautiful and formal. . . . What you saw were simply rows of small white rectangles tacked to the wall.

WEGMAN: Tacked but not brutally tacked.

ROSS: Just elegantly.

WEGMAN: Not even elegantly.

ROSS: Just . . .

WEGMAN: . . . routinely.

ROSS: But not industrially.

WEGMAN: No.

ROSS: But the drawings themselves were filled with pathos. You were observing the pathetic failure of language, the condition of Postmodernism. They projected that pathos. They were never really cartoons, yet they often were seen as funny because of their primary ambiguity.

WEGMAN: The theme in my drawings keeps changing in the way that I do. Those first drawings were more about form—lists and statistical info. How to dot i's. Then later how to gouge them out with a bird beak.

ROSS: Not to change the subject, but in your photographs you tend to be more clean-cut.

WEGMAN: Well, yes. In those that play off convention.

ROSS: The family unit, for instance, with Gayle [Wegman] and Man Ray.

WEGMAN: I liked to keep a matter-of-fact directness in those pictures.

ROSS: In order to . . .

WEGMAN: Invert it.

ROSS: Subvert?

WEGMAN: Not in the way you are implying.

ROSS: There was a time when your work would have been categorized in those Conceptual, essentially anti-photography shows using photographs which were all about undermining the photographic image, its history and

FAMILY COMBINATIONS. 1972. Six photographs

22

its veracity.

WEGMAN: Right.

ROSS: But then in fact the work grew past that to the point where it established itself as real photography.

WEGMAN: In the Polaroids.

ROSS: Yes. Before that they were clearly not to be shown as fine art photographs matted and framed.

WEGMAN: Just tacked to the wall.

ROSS: But not brutally tacked.

WEGMAN: Just routinely. They are fine art photographs, not fine photography photographs.

ROSS: The Polaroids are slick in comparison. They are similar to the spirit of the early videos in the way they play off advertising conventions.

WEGMAN: The slickness is a given. It's just the way they come out of the camera which is what I really like about Polaroid. It has its own highly unique quirks. To me it's very much like video. At least in process.

ROSS: You mean with the instant feedback potential.

WEGMAN: Yes, and what that process opens up.

ROSS: The spontaneity.

WEGMAN: And zeroing in or honing in on something. Really getting to it. I should thank John Reuter who has operated the camera for the last ten years, and those before him—Roger Greguire and Joanne Verberg who introduced me to the camera in Boston. I really resisted at first. I had never used color before. In fact the first few days I used it I made black on black. Ray under a beach cloth against a black background. It was an act of faith for those that wanted a dog picture.

ROSS: And your beautiful models.

WEGMAN: Hester Laddey and Eve Darcy.

ROSS: and . . .

WEGMAN: Lindsay Ross.

ROSS: Whose misfortune it was to be in those photographs without the dog.

WEGMAN: Nevertheless, while we are giving credit, she really made those pictures. They are among my personal favorites.

ROSS: And what about the return to painting. Who can we thank for those?

WEGMAN: Well, we could start with David Davis. The New York City art store where I buy my painting supplies.

ROSS: What kind of canvas do you use?

WEGMAN: The finest cotton.

ROSS: And paints? Do you grind your own?

WEGMAN: No, but my assistants do. All I have to do is paint in the little leaves and hairs. My assistants do all the rest.

Videotapes: Seven Reels

Video is exciting because it's so much like TV. But unlike TV, you have to make it yourself and it can be expensive. You can get others to help you or borrow your equipment from school. You might find that others aren't interested in your video programs. If you own your own equipment it can become obsolete and if you don't use it often it can be confusing to operate. Whatever you use, be sure to get a good microphone. Good sound is a good investment; cheap audio is a dead giveaway regarding quality. Nobody likes bad sound.

I first got into video at the University of Wisconsin, Madison, in 1969. I used a video camera and recorder made by an electronics company named Craig. I remember the name because it sounded like a boy's name. The necessary equipment — camera, recorder, monitor, and microphone — was in separate components that had to be hooked up properly to work.

Video offered a way for my work to acquire uniformity. I was particularly perplexed by the scale problem. Big is good but hard to store. Small, nobody gets to see. Video exploded the whole issue of size and scale. With my photographs reaching others through publication, the videos could in turn be broadcast. At the time this was hypothetical, but the belief that I could reach an audience without being there somehow appealed to me. I was also interested in expanding the range of subject matter in my work; to deal with things that really meant something to me, the kinds of things you tend to catch yourself thinking about whether you're supposed to or not. Video was ideal for that.

The first video equipment that I owned myself was something I picked up at White Front in L.A. It was housed in a box by GE but deep down it was a Sony CV format. I used this deck for two years, and on it produced a 30-minute compilation of short works which are in Reel 1 (1970–72). I also gleaned an additional collection of these works for a collection that I edited in 1983 called Pre–Reel 1.

My primary preoccupation with video lasted through seven reels made over seven years. All the reels are comprised of brief vignettes involving studio and familiar household props. They are unassuming and straightforward in set and lighting, with clear and definite beginnings, middles, and ends. Reel 1 consists mainly of visual puns and manipulations of logical constructs.

Reels 2 (1972), 3 (1972–73), and 4 (1973–74) are more audio oriented than the earlier works, given somewhat to a fascination with narrative. Usually the image came first and a narrative was thought up to accommodate it. They were made on a Sony Av3400, supposedly an improvement over the CV format. The deck is somewhat lighter than the CV but other than that I can see no technical advantage. I did however get carried away with the Electrovoice RE-15 microphone which reproduced a much clearer voice tone than my $12 comes-with-it model. I moved from L.A. to New York between reels 3 and 4, so I switched from T-shirts or no shirts to sweaters. As a unique strategy, I played around with overdubbing.

Reel 5 (1975) is dark and obtuse. It was made on a Panasonic deck in New York in my studio on Crosby Street. I had been experimenting with herbal recipes; the concept of dumbness; convoluted, fractured monologues; and a little bit of camera movement. It has the aura of cabin fever about it.

Reel 6 (1975–76) was made at two locations, the WGBH workshop in Waterville, Massachusetts, and my studio at

Thames Street in New York. The videos made at the workshop employ rudimentary but more tricky electronic matting devices. FURNITURE, for example, uses futuristic jargon to describe what it will be like in the future ("everything will be push-button"). The colorized and electronically matted and masked image of a rocking chair and Victorian headboard are visual examples of this future world. By far the most well-known work from this tape is TWO DOGS, sometimes known as DOG DUET. Two dogs stare at something off camera and begin to follow its movement. They are at times in perfect sync and at others in counterpoint to one another. What made this production exceptional was working in the presence of others.

The first all-color reel is Reel 7 (1976–77), made on a Sony ¾″ U-matic. One of the themes of Reel 7 is familiarity and remembering, as in ALPHABET. Works like BASEBALL OVER HORSESHOES and HOUSE FOR SALE have a "harkening back to an earlier, simpler time" quality about them. Some, in fact, are remakes of older videos: ALARM A and ALARM B recall WAKE UP (Reel 4). The nose/mouth/face character in BAD MOVIES, ALPHABET, and OH BOY, FRUIT is straight out of CONTRACT (Reel 1). PIANO HANDS is reminiscent of Reel 5.

GREY HAIRS was made in Boston at WGBH using 2″ equipment. It is a series of long, slow pans over the contours of Man Ray. These takes are overlaid in editing, creating pulsating moire patterns and syncopated breathing sounds. Because of its length, it was not included in the annual reel collections and is often coupled with THE ACCIDENT (1978) and MAN RAY MAN RAY (1978). In THE ACCIDENT, three actors give eyewitness accounts of a gruesome car accident. One of the three actually witnessed the accident; the other two are merely repeating the first's description. The struggle to remember these overheard details produces facial expressions very like those of the actual witness. THE ACCIDENT could be considered a study in directing technique. MAN RAY MAN RAY details events from the lives of my Man Ray and the man Man Ray. Russell Connor, a familiar arts commentator, delivers the narration in a straightforward manner. Still slides and video old and new are mixed with the commentary to give a particularly blurred portrait. WORLD OF PHOTOGRAPHY was cowritten by video/performance artist Michael Smith and myself, and was first aired on Alive from Off-Center on PBS in 1985. It explores the relationship of an amateur photographer named Mike, played by Smith, with a professional played by myself. Mike comes to me wondering if he has the aptitude for photography, and through a series of suggestions and evaluations, his question is answered.

DOG BASEBALL was commissioned by NBC's Saturday Night Live in 1986. The game takes place on a farm in upstate New York. It pits nine dogs against me in a game "just for fun." This work differs from the earlier reels in many ways: It was shot in 35mm film and transferred to video, and then mixed with a narrative and music in professional video and sound studios. But DOG BASEBALL proceeds logically from a preposterous premise, in keeping with the spirit of the earlier reels.

My video work can be likened to Plato's DIALOGUES, only my work is primarily with dogs. According to Plato, art had no place in his ideal society. In mine, it would be right near the top. In my society, dogs would be allowed to ride on buses and trains like they do in Holland.

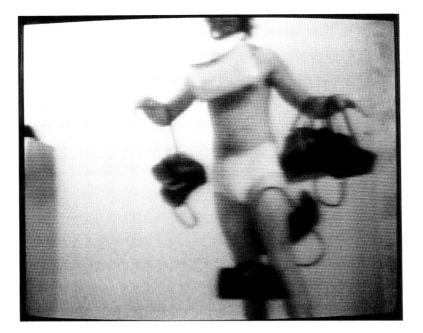

Part I: (Boy #1)
—Oh Mom! The Pocketbook Man is here!

Part II: (Boy #2)
—Hey Mom! Dad's home!

(Enter Pocketbook Man):
—Oh wow, what a day. Help me get these things off, Johnny. Oh God, I didn't sell anything. What's for dinner? Oh great. This is really too much. Oooh, man. How'd you do? Oh yeah? Let's see. Oh my [I'm] bushed.

Reel 1: POCKETBOOK MAN

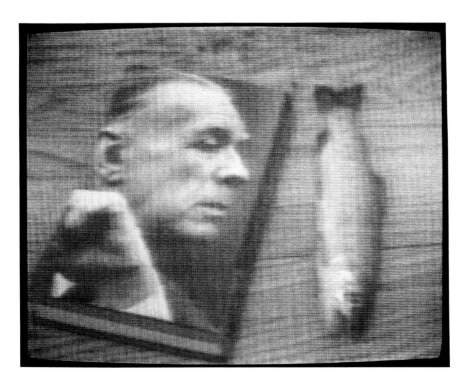

As all Egyptians knew, Abtu and Anet were two life-sized fishes, identical and holy, that swam on the lookout for danger before the prow of the SunGod ship. Their course was endless: By day the craft sailed the sky from dawn to dusk; and by night, made its way underground in the opposite direction.

Reel 1: ANET AND ABTU (Text from Jorge Luis Borges, *Book of Imaginary Beings*)

—Oh mom? Mom? I think Randy's going to be sick. (Lamp falls.)

Reel 1: RANDY'S SICK

Reel 1: MILK/FLOOR

Reel 1: STOMACH SONG

Reel 1: HOT SAKE

Reel 1: NOSY

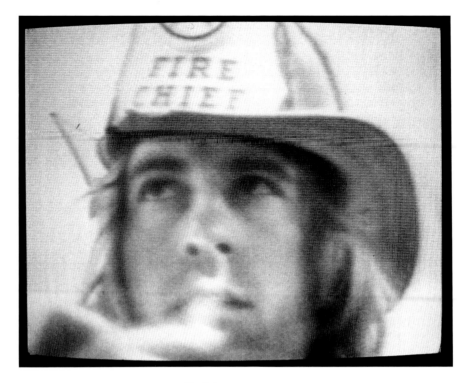

Reel 1: FIRE CHIEF

—There you are. Time to go.

—What?

—Don't you remember me?

—I don't remember you.

—Sure you do!

—You're making a mistake. You're confusing me with somebody else.

—I never forget a face! Let's go!

—Couldn't you come back for me tomorrow? I have some things to do
. . . take care of some business and see some people . . . stuff like
that . . . then I'll be ready to go.

—That's what you said the last time and you ran away! You're not going

to trick me this time! I'm right here! And I'm going to watch you!
And we're going to go in just a minute so say goodbye!

—I've been thinking it over and I would rather not go, actually. I've been
thinking it over and . . .

—We made a contract! Don't hedge!

—Let me call up my lawyers and stuff.

—Too late for that! You signed! And it's time to sign off! Sooo . . . say
goodbye!

—(No.)

—Yes it is! Say goodbye!

—Goodbye.

Reel 1: CONTRACT

Reel 1: PUPPET

Reel 1: CAPE ON

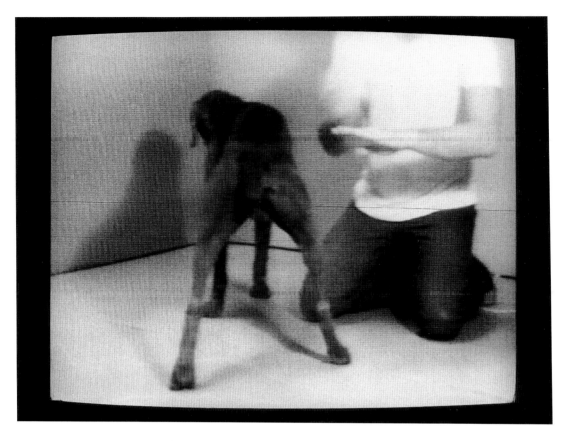

Reel 2: COIN TOSS

—Where were you? We were looking all over for you.

—I went shopping.

—Oh, what d'you get?

—I got a new shirt.

—Looks nice.

—D'you like it?

—Yeah, it's a great shirt. It's kind of big on you though, isn't it?

—Well, once I wash it it'll shrink down to my size.

—That shirt's not going to shrink, it's Sanforized.

—Well, if it doesn't shrink I'll bring it back and get a smaller shirt.

—Well, I don't think they let you take things back once they're washed.

—Well, I'll make up some story then if it doesn't.

Reel 2: SAME SHIRT

—Hey Bill.
—Yeah.
—Where are you?
—I'm in the cup.
—All right, I'll talk to you later.
—All right, see ya.

Reel 2: IN THE CUP

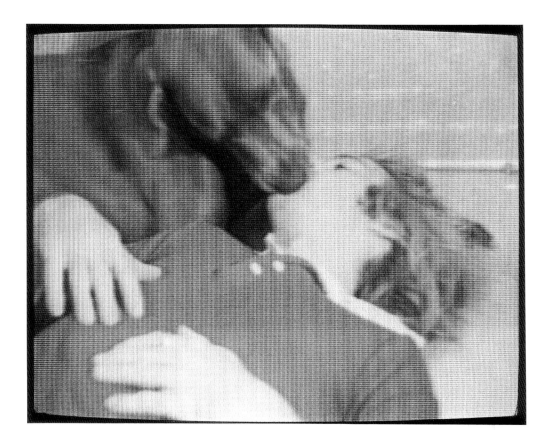

Reel 2: THE KISS

So what am I going to do? I had these terrible fits of rage and depression all the time. It just got worse and worse and worse. Finally, my parents had me committed. They tried all kinds of therapy. Finally they settled on shock. The doctors brought me into this room in a straightjacket because I still had this terrible, terrible temper. I was just the meanest cuss you can imagine. And then when they put this cold metal electrode or whatever it was to my chest I started to giggle. And then when they shocked me it froze my face into this smile. And even though I'm still incredibly depressed, everybody thinks I'm happy. I don't know what I'm going to do.

Reel 3: RAGE & DEPRESSION

I took a speed-reading course. What you do is they teach you to read only important words—that way you scan. Also, they put a transistor in your nose and you read with your nostrils as well as with your eyes. What happens is it decodes difficult words—sends them up to brain. Read . . . read *Remembrance of Things Past* in 45 minutes! Whole thing! Read *War Peace* (Tolstoy) in half hour! With new speed-reading course, they insert um . . . uh . . .

Reel 3: SPEED-READING

I was born with no mouth at all, just a kind of plane across my face. I did have a well-developed nose when I was born. Actually I did have a mouth; it was more like just a little slit about an eighth of an inch wide. Hardly even a sixteenth of an inch high and my parents just figured that gradually it would develop, that it would grow into a real mouth. But by the time I was six they could see it wasn't going to happen. They were afraid to send me to school with a mouth like that, so when my grandfather died when I was six, they transplanted his mouth onto mine, took out my mouth, and I think they gave it to the University of Massachusetts. So I've been shaving ever since I was six.

Reel 3: BORN WITH NO MOUTH

Of all the deodorants, this is the one that I enjoy using the most. It feels real nice going on, and smells good, and keeps me dry all day. I don't have to worry about it cutting out at clutch moments. All the other ones are just, oh, they just never seem to hold up under pressure for me. I can put this on once during the day, and for the rest of the day I'm fine. I'm all set up; I don't have to worry about, you know, social nervousness or anything. It's just . . . It keeps me feeling good and fresh. I love the smell. I don't think there's any deodorant that comes close to this one.

Reel 3: DEODORANT

Reel 4: WAKE|UP

For the most part, the trip across the country is really pretty boring. You go through a lot of little towns and it's mostly flat. You know, I thought that there'd be, uh, more green. It's that kind of arid, dry, brown dull. It's really boring. And the food, especially along Route 66, we had some really terrible, awful dinners. But then we got to the Grand Canyon — now that's another story. That is really overwhelming. In fact, I never forgot the Grand Canyon . . . I can still see it now. It's uh, truly amazing. But other than that, there wasn't much else to see.

Reel 4: TRIP ACROSS COUNTRY

I'm here today to tell you about the three movies I saw yesterday. The first movie that I saw was basically a circular movie that went around and around, and back and forth. It was a very enjoyable movie. The second movie that I saw went, more or less, back and forth, depending upon whether . . . well let's skip that one and go on. The third movie that I saw was one that started out going around, back and forth, and ended up upside down. And those were the three movies that I went to. But I liked the first one.

Reel 4: SAW MOVIES

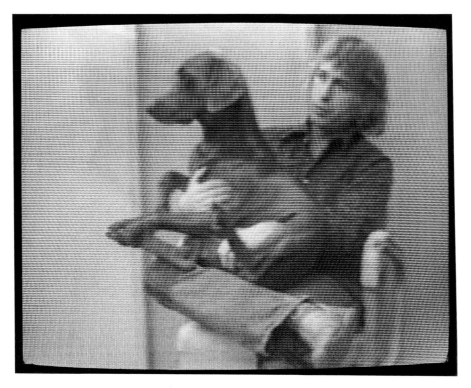

I am lifting this eighty-pound dog onto my lap and I'm trying to talk normally even though the pain from the weight of the dog is almost unbearable. It's very hard to talk and keep a straight face with the dog on my lap because he fidgets so and he tries to get away, he tries to break out of my grip but I have him securely locked in my arms. I'm trying to sell you a new or used car from our downtown lot and trying to talk you into buying one and I hope that if perhaps if I have this dog on my lap you'll come to see me as a kind person, because a mean person . . . if I was a mean person and a shark so to speak, this dog wouldn't let me touch him and paw him so; he'd uh, he wouldn't have such faith in me. And so too, just as this dog trusts me, I would like you out there to trust me and come down to our new and used car lot and buy some of our quality cars. I know you'll be satisfied. Thousands of others have been. Thank you for listening.

Reel 4: NEW & USED CAR SALESMAN

Reel 4: GROWL

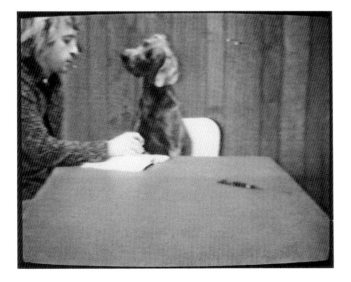

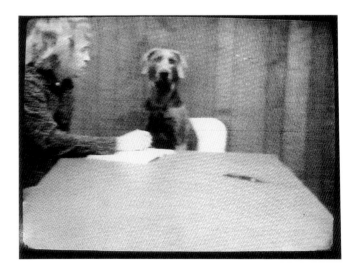

P-A-R-K was spelt correctly. *Wait* a minute. And you spell O-U-T right. But when it came to B-E-A-C-H, you spelt it B-E-*E*-C-H, which is like . . . uh, well, there's a gum called beech-nut gum, but the correct spelling is . . . we meant beach like the sand, like the ocean, so it should have been B-E-*A*-C-H. (Man Ray whines.) You see, that's the difference. Well okay, I forgive you, but remember it next time.

Reel 4: SPELLING LESSON

—I know you're really busy and everything, but will you be giving any concerts in America within the next few weeks or so?

—Well, I'm booked up pretty heavily, but I do hope to come to the States towards the end of November. I have a concert to do in Italy and in Amsterdam, and in Rome, and also in Holland.

—Holland? Isn't that where they have the waterways and all of the canals? Or is that in Venice? Did you say that you were going to Venice and to Amsterdam?

—No, I said that I was going to Holland and to Italy.

—Can I ask you something? Are you right-handed or are you left-handed?

—No, I'm ambidextrous.

—I was—you tend to play the low notes with your left and the high notes with your right hand. So, I was wondering . . . are you right-handed or left-handed?

—No, I'm ambidextrous, but it's easier to reach the lower keys with my left hand.

—And the high notes with your right hand. . . . So, I was wondering, are you more anxious to go to Italy or to Amsterdam?

—I'm not real excited about going to Amsterdam, per se, but I've never visited Holland, and I've been to Rome several times.

—So you'll be more anxious to go back to Rome?

—I'm looking forward to visiting Holland even though I'm not terribly interested in Amsterdam because I know I get confused between . . . I confuse it with Venice all the time with the gondolas. But if you go in the winter, the rivers will be frozen in Amsterdam and not frozen in Italy.

—That's true.

—That's why I play the lower notes with my left hand and the higher notes with the right hand.

—What's a nocturne exactly?

—It has something to do with night. It's a kind of music that we like to play at night. It sounds like a German word. I'm not really sure where the word comes from. It does sound German, doesn't it?

—Will you be doing any concerts in Germany?

—Well, I just did a concert in Germany . . . I probably won't for another . . . after I get back from Holland and Rome, I might like to go to Germany again because I was well-received there.

—But I thought that you'd come to America. Now you're saying that you're going to go to Germany.

—Well, I said that I wouldn't mind going to Germany. Of course, I'd like to come to America.

—We were talking about nocturnes. Are those the only things that you play, the nocturnes? That's all I've heard of yours.

—No, I play also études and waltzes, a few polonaises. I don't know all of them—there are so many.

—Do you know any mazurkas? What's a mazurka anyway?

—You don't know what a mazurka is? If you don't know what a mazurka is, then you don't know what a nocturne is either because I've just been playing you a mazurka.

—Thank you for taking time to visit with us.

—Thank you.

—Let's see, there was Rome, Amsterdam, America, mazurkas, nocturnes, études, scherzos, and polonaises.

—A few polonaises.

—One . . . three polonaises and a mazurka.

Reel 5: NOCTURNE

Reel 6: VIDEO

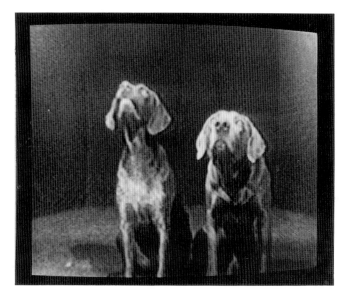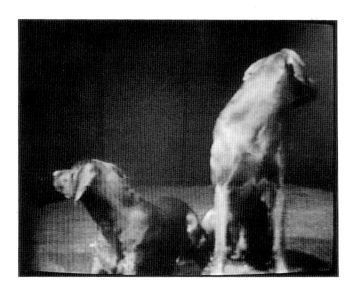

Reel 6: DOG DUET

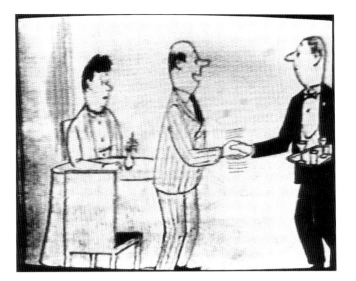

Reel 6: JOKE

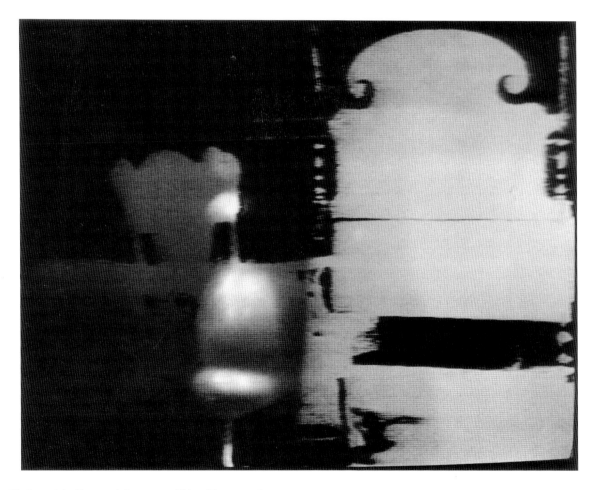

With the aid of special effects and drugs we will be able to see shapes and colors we never saw before, colors we never thought existed before, and shapes we never imagined or drugs we never took, special effects we never used before. Furniture, with the aid of new technology, we will be able to see into the future so that we may better control that which we may so desperately need to predict and control our lives and environments in the future. And so everything will be push-button and all we will need to do is push a button and the profile of the future will become a full face.

Reel 6: FURNITURE

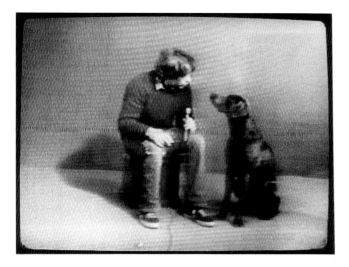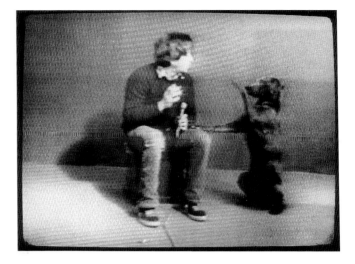

Goodbye.

Come here. Sit.

It's good, once you get the hang of it. Really, you'll like it. Just inhale. Kind of swallow the smoke. Like this. Watch. (Bill inhales.) Watch Ray. (Bill exhales.) Suck it in, and then blow it out. Here. (Offers cigarette to Man Ray.) Try it. How do you know if you don't try it? It might be good. Try—give it a try. Please, for me. Just take a puff. One puff. (Bill inhales.) Like this. (Bill inhales and exhales.) Here. You ready? Come here, Puff. C'mon. One puff. Come here, one puff. Come. Come here. One . . . For me. For Bill. Where's Bill? Give Bill a kiss. C'mon. OK, now sit. Now watch me. Watch. (Bill inhales.) Just draw it in, draw it in (Bill exhales) and blow it out. OK, now here. Just one. Here please. One puff. Here, take it. Please, for me. For Bill. Give Bill a kiss. Come on. OK. Sit. Now sit. Watch. Inhale it, don't just puff on it. Watch. Draw it in and blow it out. You can do it. You promised me. Here try it! You won't know if you don't try it. Hey! (Man Ray walks away.)

Reel 7: SMOKING

—Do you like to pitch horseshoes? It's when you try to get ringers. Throw the horseshoe towards a post, and, when you get the horseshoe around it, take two turns and then switch back to the other side. Do you like to play that game?

—I like to play more team sports. Do you like to play baseball? You get a group of guys on one side, or gals, too. I think that baseball has a lot more pizzazz than horseshoes because it's more of a team effort. I like anything that has team unity and spirits, like I think that horseshoes is much more of an individual effort, it doesn't really have pizzazz.

—Clang (PAUSE). . . . It is fun to get a ringer, but it's more fun to root for your other teammates rather than just for your own self, and when you win there's nothing quite like the experience back in the clubhouse of knowing that it was a team effort. Rather than with horseshoes, you come back and so what, you did it all yourself, but there's no camaraderie, you know, there's no pizzazz.

Reel 7: BASEBALL OVER HORSESHOES

I wanted to find out how much wood a woodpecker could peck compared to that of a . . . to how much wood a woodchuck could chuck and it turns out that a woodpecker can peck as much wood as a woodchuck can chuck relative to their own size.

Reel 7: PECK & CHUCK

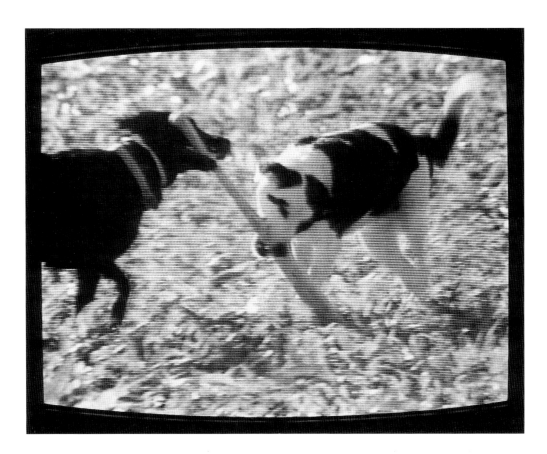

DOG BASEBALL. 1986. Made for Saturday Night Live.

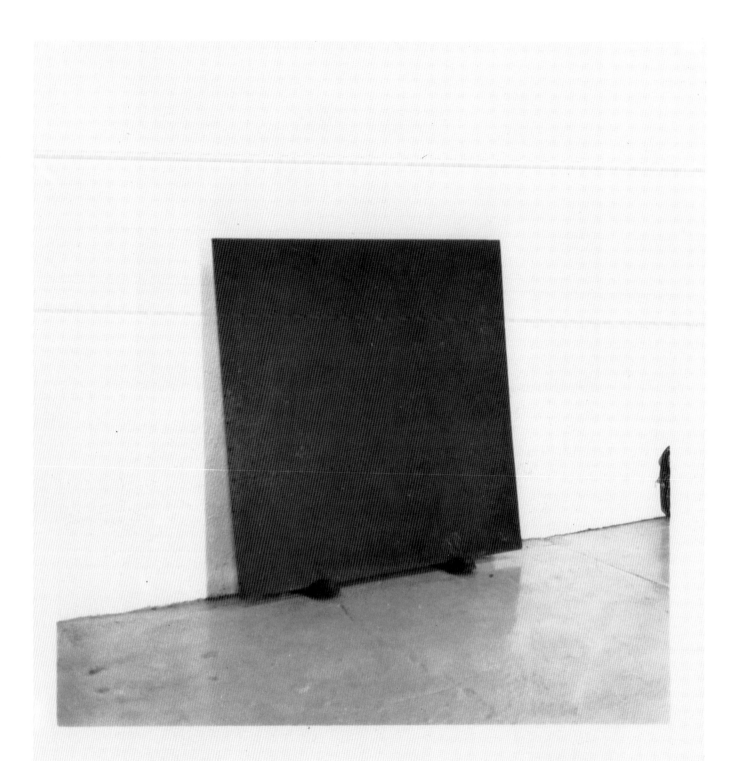

TO HIDE HIS DEFORMITY HE WORE SPECIAL CLOTHING

PETER WEIERMAIR

Photographs:
Subversion Through
the Camera

In his early works, which are extensively represented in this book, William Wegman worked with a variety of different mediums, sometimes presenting them in a hybrid form. In a review in ART IN AMERICA of a retrospective exhibition of Wegman's work up to 1982, Craig Owens emphasized the informal character of Wegman's art; his deliberate omission of artwork and renunciation of mastery. This act of rejection, he stated, is "not simply a matter of technique, rather it is often the explicit theme of his works."

Wegman's early photographic works are deliberately simple: they have the character of cartoons or illustrations. He himself says that the style of a picture is not significant, it is the subject matter that is important. If the photographs, like many works of artists of this period, for instance those of Wegman's friend John Baldessari, are documentary in nature, they merely document something that was staged exclusively for the photograph. Wegman created these single shots, diptychs, and series during the period when Minimal, Conceptual, and Process art, for which the photograph was an important means to record events in time and space, were flourishing. No importance was placed on style and composition, or the other esthetic values of art photography. But if on the one hand Wegman came from the circle of Minimalism and Conceptual Art, on the other hand he made fun of their seriousness, their ideology of reduction, and, above all, their lack of humor. For example, the photograph TO HIDE HIS DEFORMITY HE WORE SPECIAL CLOTHING (1971; opposite), which depicts a masonite square leaning against a wall and resting on two shoes, and hints that a figure could be hiding behind it, can be regarded as a clear parody of the work of the distinguished sculptor, Richard Serra.

Wegman's works from this period, however, are not totally absorbed in art-world satire, no matter how many cross-connections can be made with the work of Serra, Sol Le Witt, Carl Andre, or Robert Morris. Dennis Oppenheim, a contemporary of Wegman's, quite rightly observes that Wegman's great achievement was that he chose to use humor. But no matter how much the concept of humor is repeatedly overused in discussions of Wegman's works, and no matter how much he employed forms of folk humor and wit and their language patterns, it is difficult to describe—much less to categorize—them with expressions such as parody, burlesque, grotesque, wit, or humor. His early works have no personal or autobiographical content. A typical feature of these works, and this holds true for all of Wegman's work, is that they do not relay a precise message, although they deliberately use terse illustrative means, a demonstrative sequence of photographs, or a comparison. Their meanings can be found on different levels, one of subject matter (the action, the dialogue, the objects), one inherent in the use of the medium itself. Both are connected and influence the way we react to them. Wegman starts with the supposition that our consciousness is partly controlled by the medium of photography as a system of symbols, and that we have internalized this medium. We always assume that photographs do not lie and tend to identify photographic reality with truth. Many artists of the 1960s and '70s have examined this topic and have scrutinized the medium with the medium itself. The photograph is a shadow of reality, light makes its existence possible. In CROW (1970; page 51), a witty apposition of a stuffed bird with a shadow that does not belong to it, Wegman not only suggests that birds are able to recognize the shadows of their enemies, but also that the photograph itself is an illusory shadow.

Wegman's early and later period—if one considers his later period as beginning in 1979 with the Polaroids, where he arrives at much stronger pictorial solutions—bear a more than cursory resemblance, in the sense that the central ideas revolve around the transformation of various subjects or the similarities between them. He is interested in the comparison of two related, structurally similar situations, in the blurring of concepts, in topics of disguise, in twins, in the transformation of identity (The Dog as Elephant) or, the change-over of sexes in androgynes (The Bodybuilder as Waitress). D. A. Robbins quite rightly observes, in ARTS in 1984, that the same impulse that leads him to undermine the credibility of the photograph prompts Wegman's attack on the way one experiences reality.

"Two equal things are going on at once. I like things that fluctuate," Wegman has stated. He makes use of the diptych, consisting of two pictures that complement each other, a structure that allows him to create a pseudonarrative situation. Then he undermines this narrative situation. The first picture presents a premise, the second does not continue it, does not complete the started sentence. The pictures create an unending loop, in which the portrayed subject seems to be permanently caught. Those who know of Wegman's predilection for popular encyclopedias, elementary "How to" manuals—the cover of a recent exhibition catalogue bore the title of a popular world encyclopedia—will find the origins of the concise pictures explicable. However, what in an encyclopedia can be seen as a catalogue of answers reduced to simple formulas is in Wegman's eyes a catalogue of questions posed to a reality that remains hermetically closed, and onto which we can impose our identity. Questions are posed, answers are not given. As he himself has said, he is interested in the reversal of the familiar: "To express whole systems of thought referring to things or situations in order to disturb the systems, which codify the ways we perceive socialized reality."

Apart from the early black-and-white photographs—works that have no claim to photographic style, composition, often not even optimal photographic development in the technical sense—Wegman created altered photographs that he saved from destruction by retouching: "Well I'll take this photograph and then I'll draw that into it. I just either take a snapshot or will just do a lot of shots. If they don't work out, I'll have them around and just look at them for a long time. Pin them up, or shuffle through them and kind of spontaneously paint into them. Sometimes they work out. It's kind of a salvaging process."

In the altered photographs, Wegman also introduces two levels, as he does in his straight photographs. Even in the relationship of the two mediums to one another, the idea of subversion plays a role. "When you mark a photograph with ink, you present two surfaces. To touch the surface of a photograph is striking, I think. And I always wanted the two levels to be close to equal to create a tension. They are more like drawings than photographs because the drawing asserts the meaning or the interpretation."

The Polaroids of Man Ray represent a turning point in Wegman's art. In his work with the Polaroid camera—which called for teamwork in the production of the photographs (model, lighting specialist, cameraman, artist)—he renounced the austerity of his early works. An unaccustomed opulence and a pictorial quality not exercised previously became characteristic of his photography. But beneath the beautiful surfaces of the Polaroids lurks still a moralist, for whom the

inscrutable, "impenetrable" animal—Man Ray and, later, Fay Ray—is the "It" of the world, which, at best, we are able to train through our words but cannot understand.

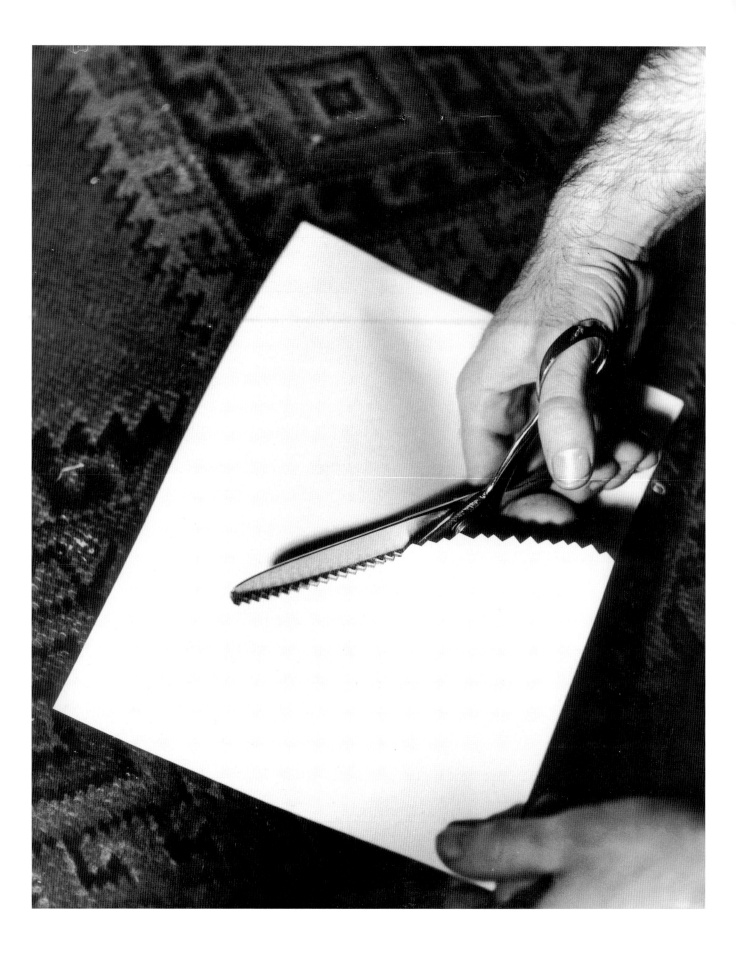

PINKING. 1974

ALAIN SAYAG

Photographs: The Invention of an Art

It could be said that, to paraphrase a famous proverb, humor is too serious a matter to be left in the hands of professional humorists. It is true that humor and painting do not usually go together very well. The Munich painter Carl Spitzweg (1808–1885), who raised the joke to the level of a true visual delirium, believed that far too many dull and unimaginative anecdotes had invaded the walls of the Salons and the pages of the illustrated newspapers of the nineteenth century. Even an artist such as Paul Gavarni (1804–1866), who was considered one of the most gifted artists of his generation by Charles and Edmond de Goncourt, is now only ranked among the interesting minor masters. This is no doubt due to the fact that humor, even visual humor, is always closely related to a specific historical, cultural, and social situation.

The "LORETTE," that young lady of dubious morals who took advantage of the older gentleman supporting her in order to give her sweetheart some tokens of her love, no longer signifies anything to anyone except to those who frequent the IXth Arrondissement in Paris and to dedicated bibliophiles. Even the Goncourt brothers noted in their journal how dated Gavarni's art appears as it attributes "all the vices of humanity to the middle classes, all political jokes to 1848, and all the faults of women to the LORETTE and the actress." In spite of Murger's SCÈNES DE LA VIE DE BOHÈME and Puccini's LA BOHÈME, the LORETTE had not become a character type who could transcend the age into which she had been born.

William Wegman, together with his dog Man Ray, and Man's descendent Fay Ray, attempts to portray precisely such a "type," in spite of its intangibility and the variety of the situations and temporal contexts in which it is found. But he does this by making use of familiar anthropomorphic examples in which animals become caricatures displaying human foibles. Wegman belongs to a long tradition that stretches from the writers of fables to taxidermists, from the fox to the frog, from literature to those TABLEAUX VIVANTS in which frogs dressed in crinolines or in tails take part in a ball at the town hall. Is it a pure coincidence that one of Wegman's most successful series is precisely the one in which he dresses his dog as a frog (page 91), as if this ridiculous fantasy of a stuffed dog which has turned into a batrachian could, by itself, sum up a very long history? But the dog is also a symbolic figure representing faithfulness. From the recumbent statues of the tombs at Saint-Dénis to the bronze dog of Shibuya Station in Tokyo, which goes on waiting for its master even after his death, the dog has always been the emblematic figure representing constancy. But can it become a symbol of derision, especially as such derision is always tempered in Wegman's work by an intense affection? If the dog is given a rough time, visually speaking, it nevertheless retains its very real dignity. This form of maltreatment could never arouse the anger of even the most vigilant and finicky "animal lovers."

Critics are less kind where the practices of some of Wegman's contemporaries are concerned. The austere and reductive minimalism of Carl Andre, the serialism of Sol Le Witt provide paradigms that Man Ray, the dog, disrupts by his presence, as in RAY-O-VAC (1973; page 58)

But the most important feature of Wegman's approach may be found elsewhere; it resides in the tension between the perfection of the technical process being employed (Polaroid photography in a room) and the grotesque or humorous nature of the playlet that is being portrayed. Wegman uses laughter to "undermine all belief, to dislodge all certainty, to discredit

all dogma," wrote Craig Owens in ART IN AMERICA in 1983, to which the artist added, "As soon as I got funny, I killed any majestic intentions in my work."

The frozen beauty of the Polaroid print has all the formal qualities of a "commercial" picture and none of the little details that proclaim it to be the kind of "artistic photograph" so beloved of my colleagues at the Bibliothèque Nationale: blurred image, unusual use of flash, bizarre framing. Quite the opposite, in fact. The object is seen frontally, the colors have that saturated and brilliant look that advertisers are so fond of; not one detail, not one aspect of the object that has been photographed eludes us. And it is this tension between the formal beauty of the photograph and the makeshift character of the arrangement that forms the basis of Wegman's approach.

That may also be the reason why, as Gene Thornton has stressed in THE NEW YORK TIMES, William Wegman is one of the few artists, beside Red Grooms, who is tolerated by those who find the hairsplitting debates of contemporary art so exasperating. Not only does William Wegman rehabilitate the subject, he also places it back into an ironic and distanced narration. In one of his early essays, "Avant-Garde and Kitsch," Clement Greenberg pointed out the degree to which the formalist investigations of modern art are related to its loss of any social significance. William Wegman belongs to a current that attempts to give an effective meaning back to the work of art. By appropriating the dominant language, the language of advertising, for his own purpose, he claims the right to treat serious subjects in a lighthearted way, subjects that include death, boredom, solitude, and what Michel Nuridsany has called the "generalized derision of the world."

All black-and-white-photographs are silver prints on 11 × 14″ sheets.

Color photographs are 20 × 24″ Polaroid prints.

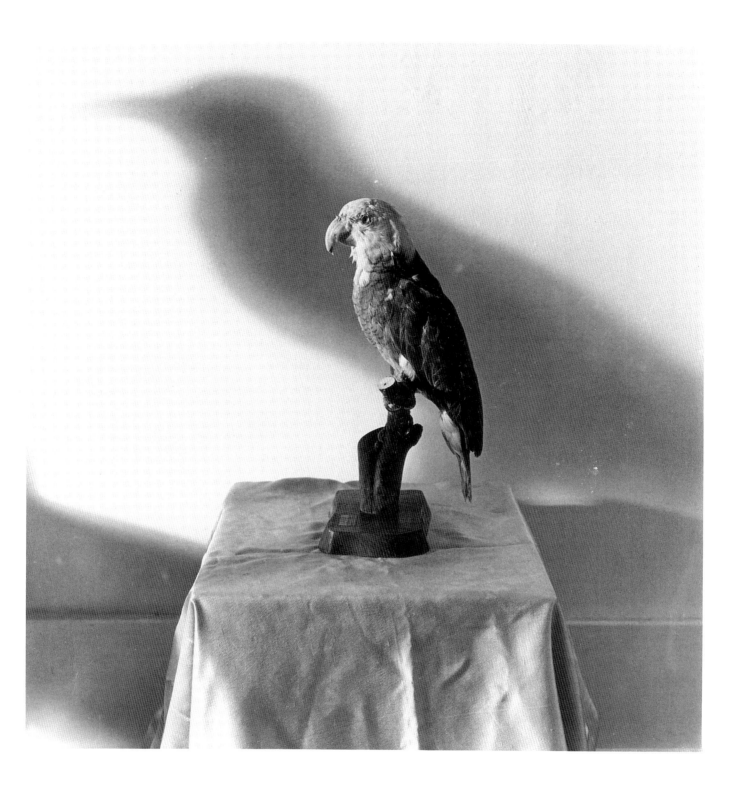

CROW. 1970. Private Collection

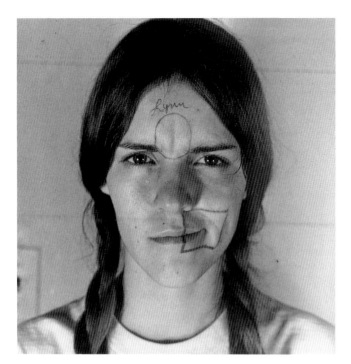
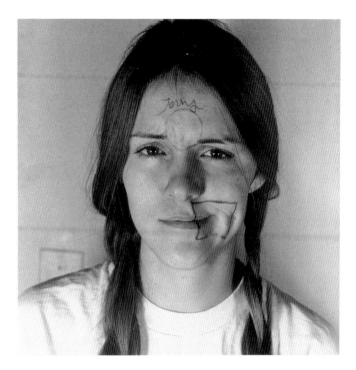

TWINS WITH DIFFERENCES. 1970

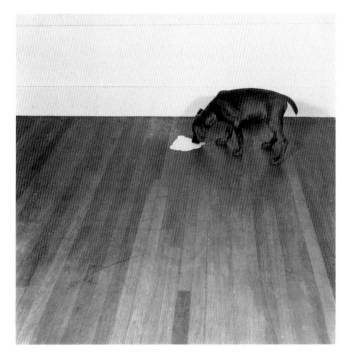
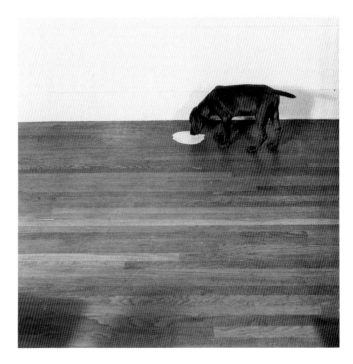

MILK/FLOOR. 1970. Private Collection

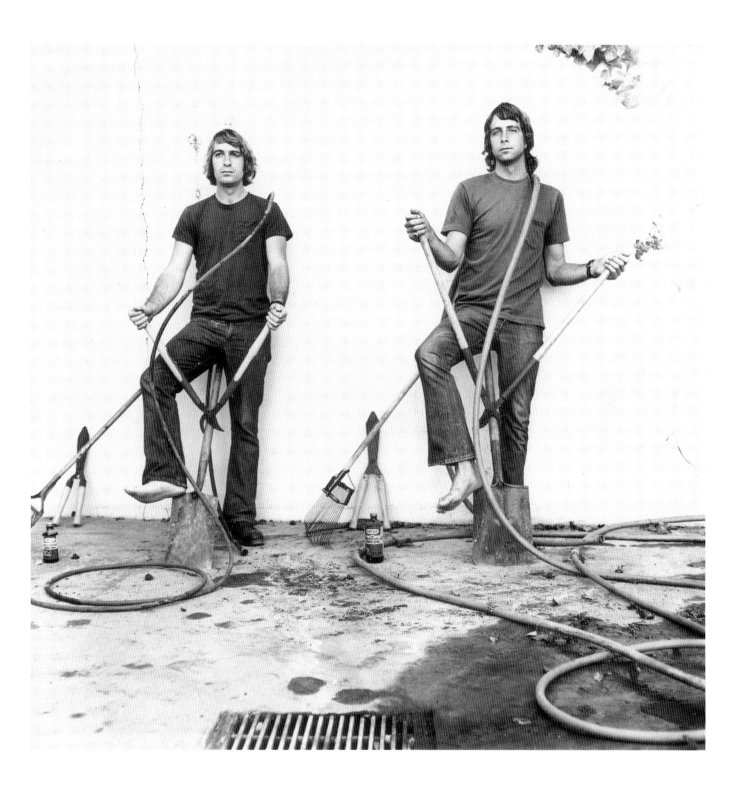

LITTLE/BIG. 1970. Private Collection

VIGNETTE. 1971. Private Collection

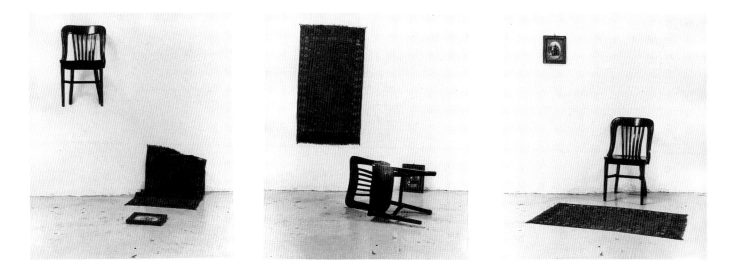

FURNITURE ARRANGEMENT. 1972

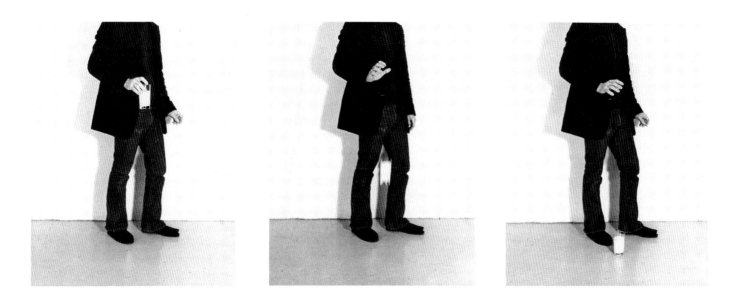

FALLING GLASS. 1972

BASIC SHAPES IN NATURE: CIRCLE. 1970

BASIC SHAPES IN NATURE: SQUARE. 1970

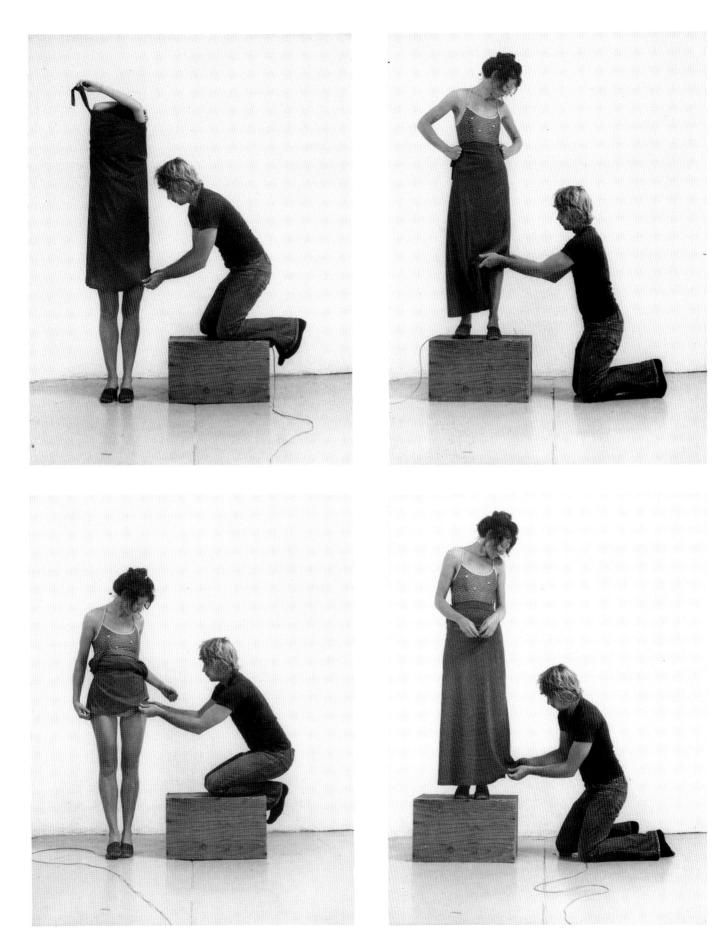

HEMS. 1971. Courtesy Holly Solomon Gallery, New York

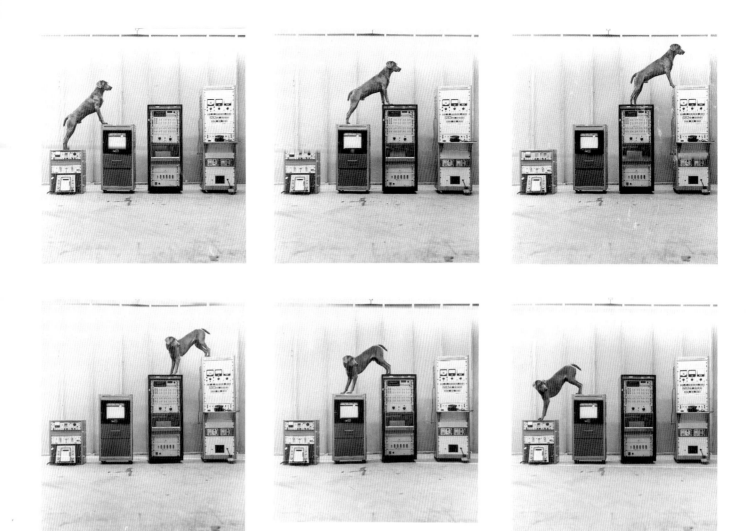

RAY-O-VAC. 1973. Private Collection

LAMB CHOP. 1973

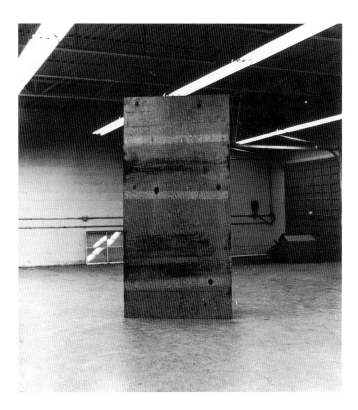

UPSIDE DOWN PLYWOOD. 1972

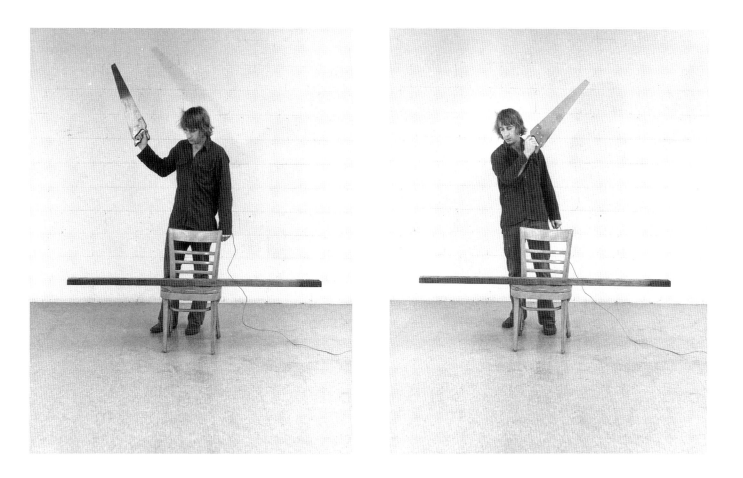

SAWING. 1972. Courtesy Holly Solomon Gallery, New York

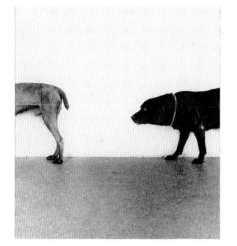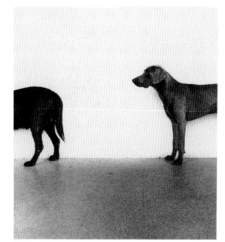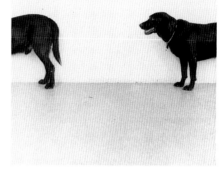

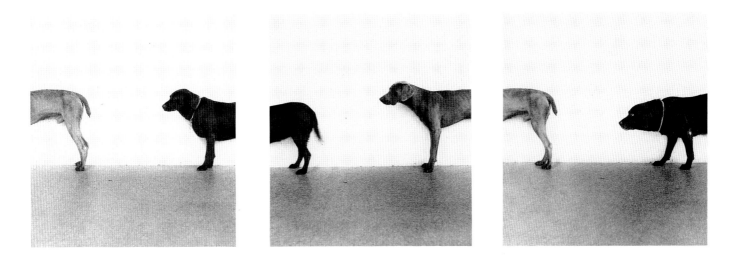

FOLLY, SOUCY, MAN RAY. 1973. Courtesy Holly Solomon Gallery, New York

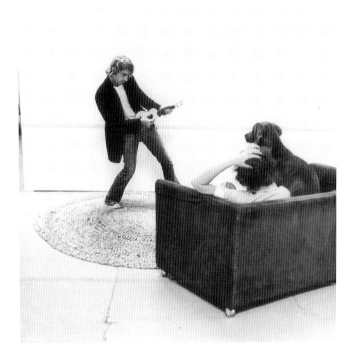

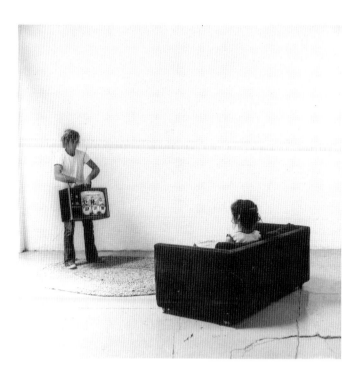

HOME ENTERTAINMENT: MUSIC. 1972.
Courtesy Holly Solomon Gallery, New York

TV. 1972

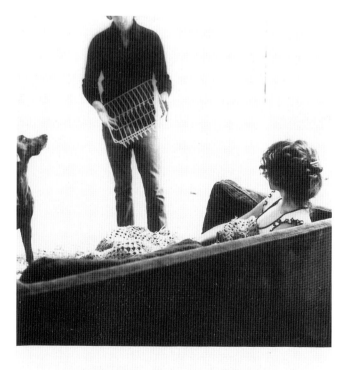

HE SHOWED HER WHAT HE MADE

HE SHOWED HER WHAT HE MADE. 1972

DOING THE DISHES

DOING THE DISHES. 1972. Courtesy Holly Solomon Gallery, New York

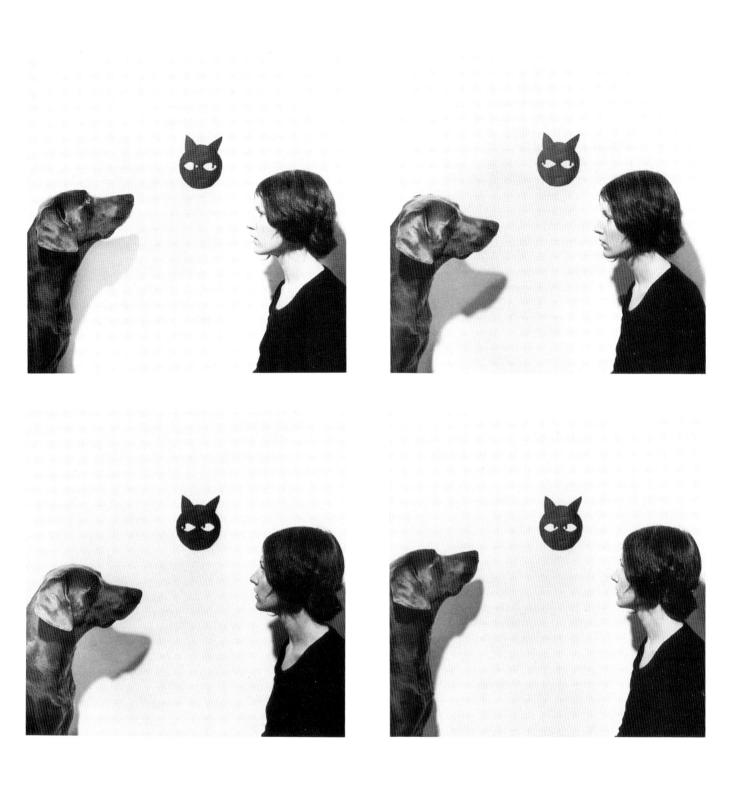

LOOKING AT. 1973

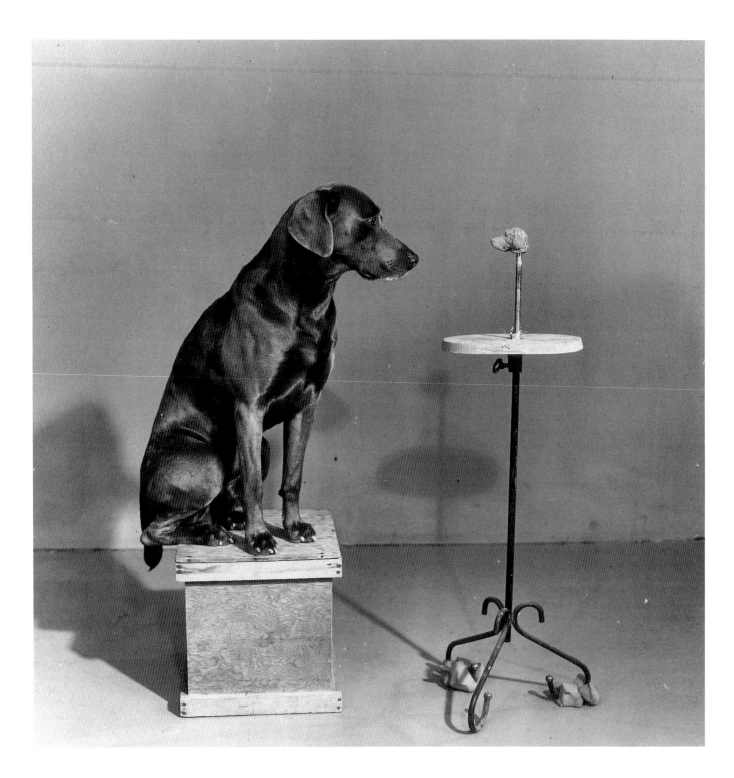

MAN RAY CONTEMPLATING THE BUST OF MAN RAY. 1978

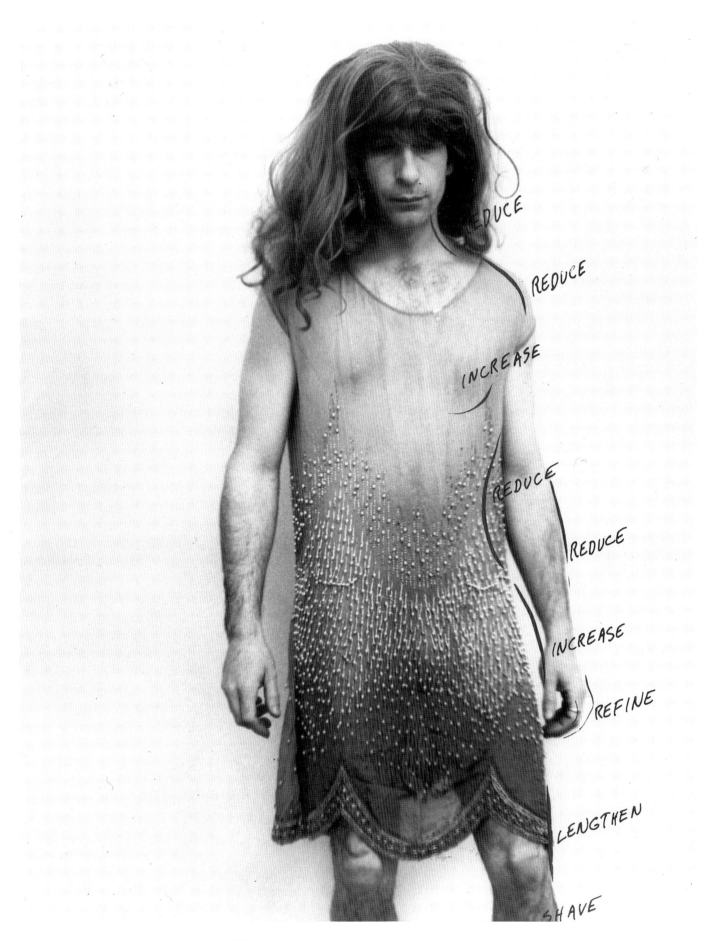

REDUCE/INCREASE. 1977. Ink on photograph, 13³/₄ × 10³/₄″. Courtesy Holly Solomon Gallery, New York

TRAVELING SALESMAN. 1976. Ink on photograph, 16 × 19⁷/₈″. Courtesy Holly Solomon Gallery, New York

STICK FIGURE. 1978. Ink on photograph, $9^3/_4 \times 12^1/_4''$. Courtesy Holly Solomon Gallery, New York

HEADACHE. 1979. Ink on photograph, 20 × 16³/₄″. Courtesy Holly Solomon Gallery, New York

PRIVATE SHOW. 1978. Ink on photograph, $9^{3}/_{4} \times 10^{5}/_{8}''$. Courtesy Holly Solomon Gallery, New York

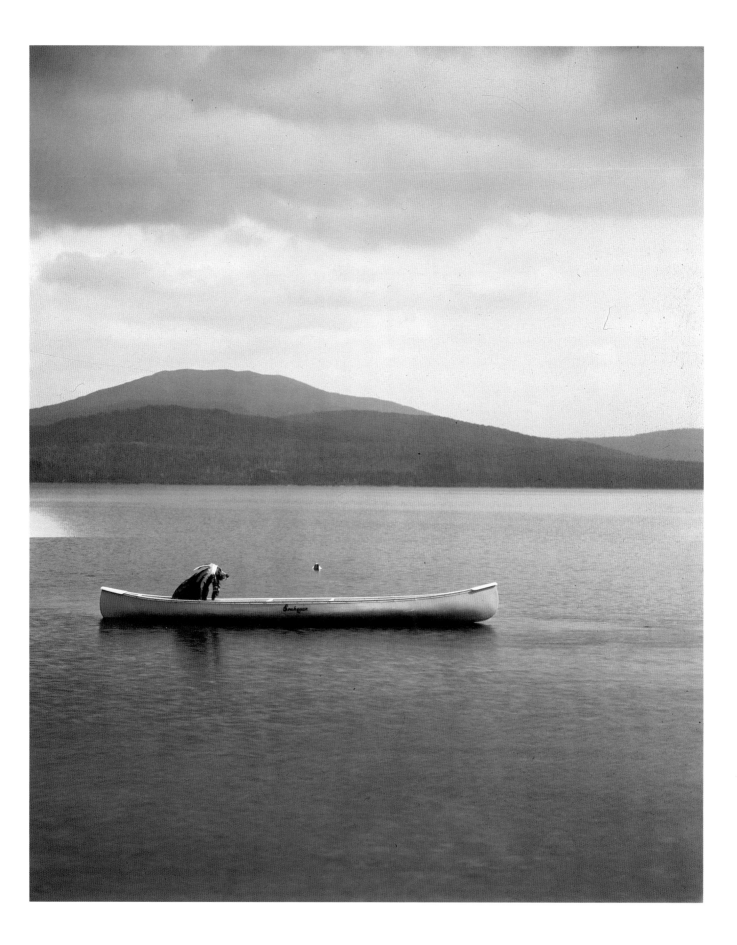

THE KENNEBAGO. 1981. Collection the Artist

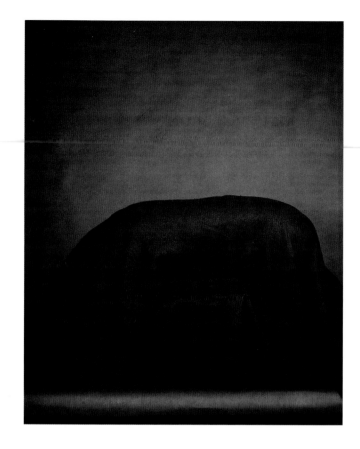

BLACK TRIPTYCH. 1979. Collection the Artist

REMNANTS. 1979. Neue Galerie der Stadt Aachen. Ludwig Collection

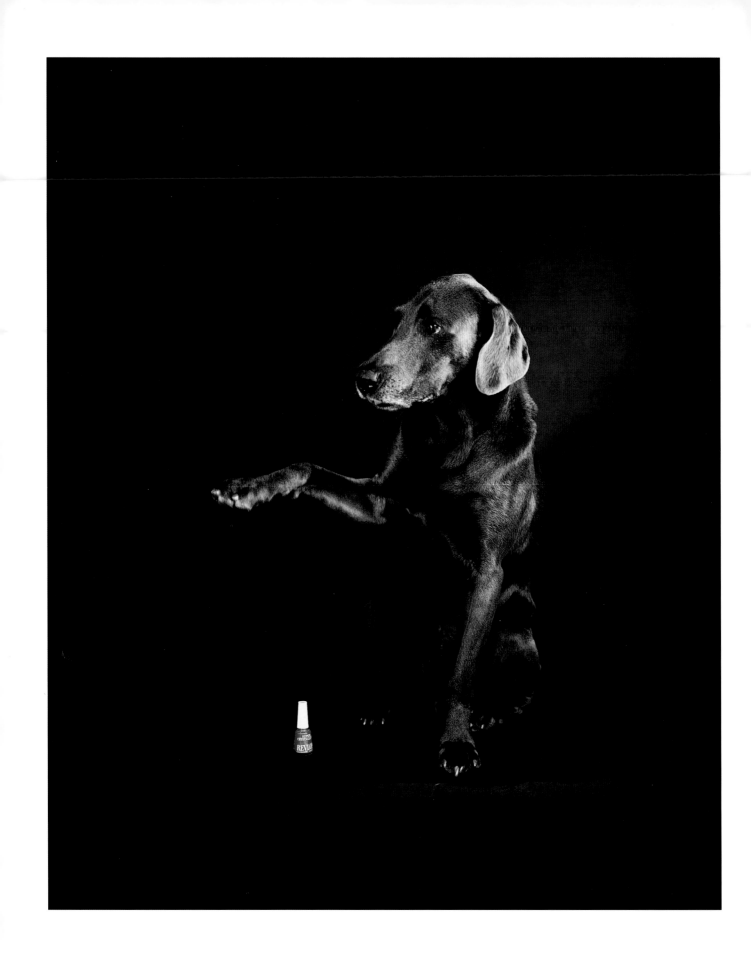

FEY RAY. 1979. Collection Twigg-Smith, Hawaii

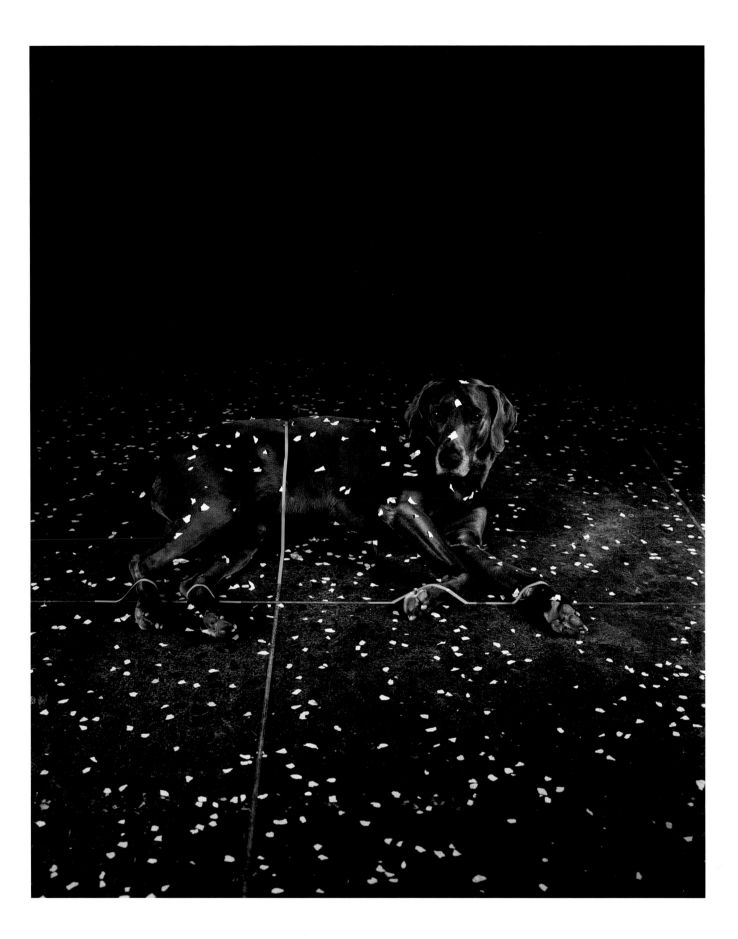

FLOOR PIECE. 1980. Art Gallery of Ontario, Toronto. Gift of Mr. and Mrs. Morton Rapp

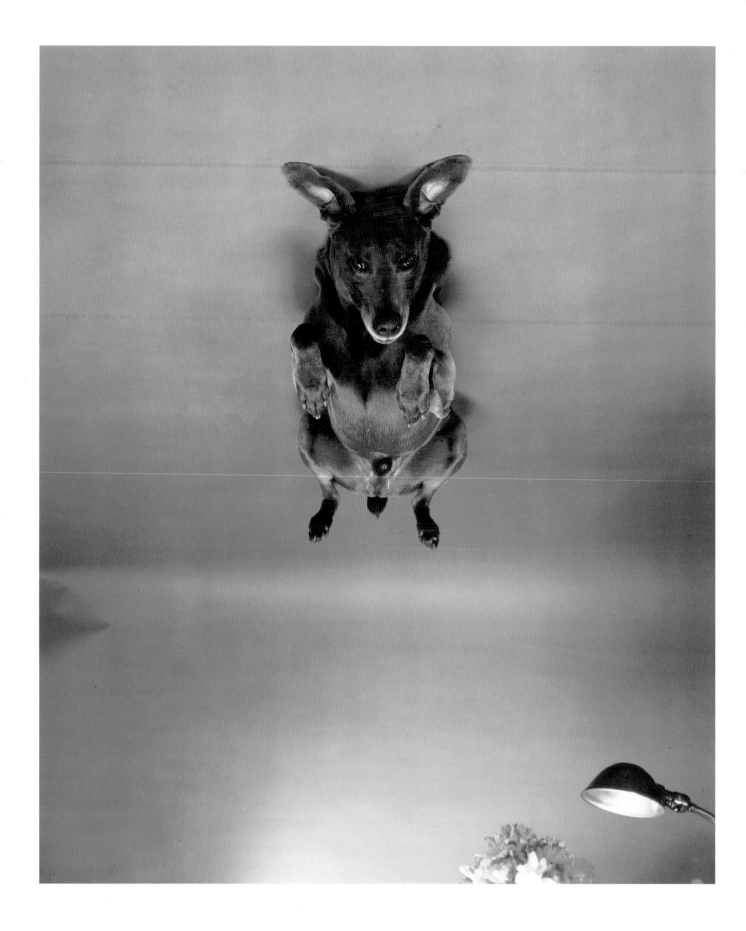

RAY BAT. 1980. Private Collection

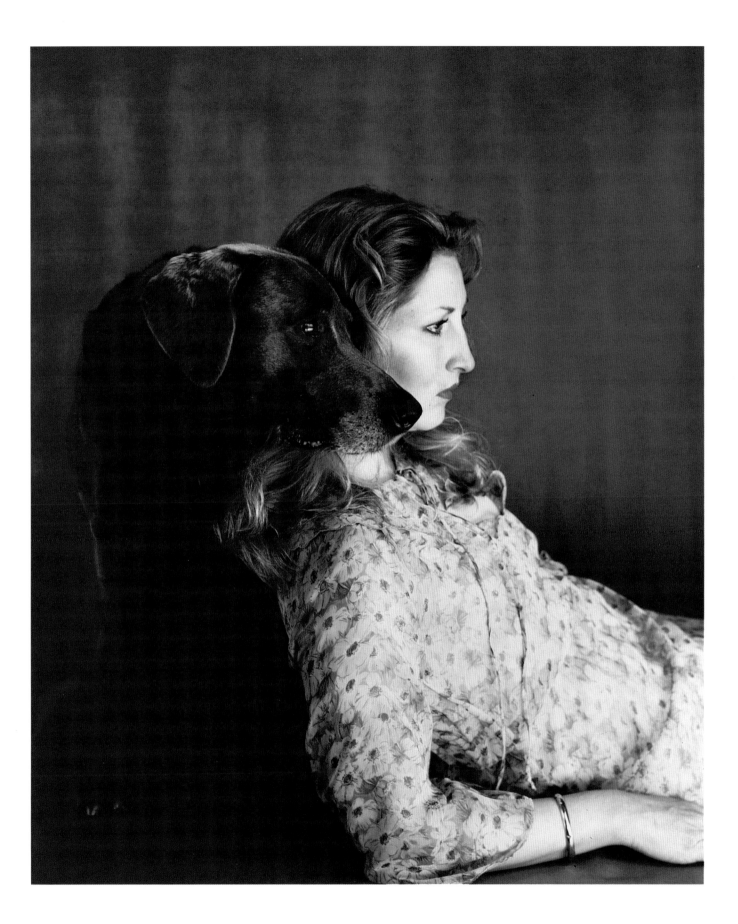

DOUBLE PROFILE. 1980. University Gallery, University of Massachusetts, Amherst
With Hester Laddy

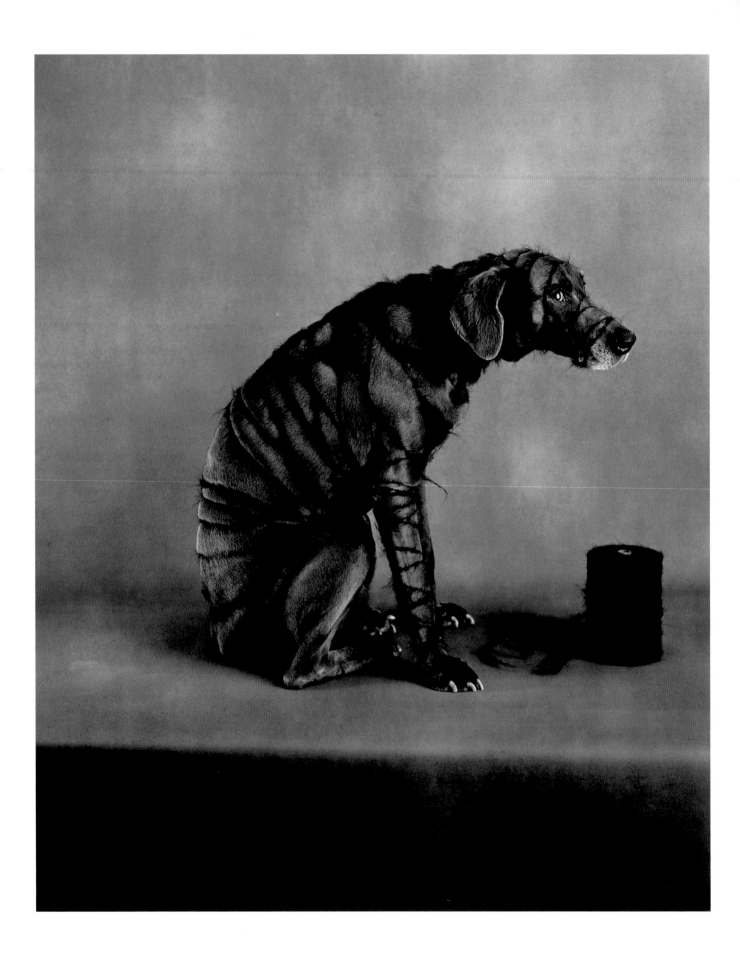

YARN (CHARDIN). 1981. Collection Steven Baker

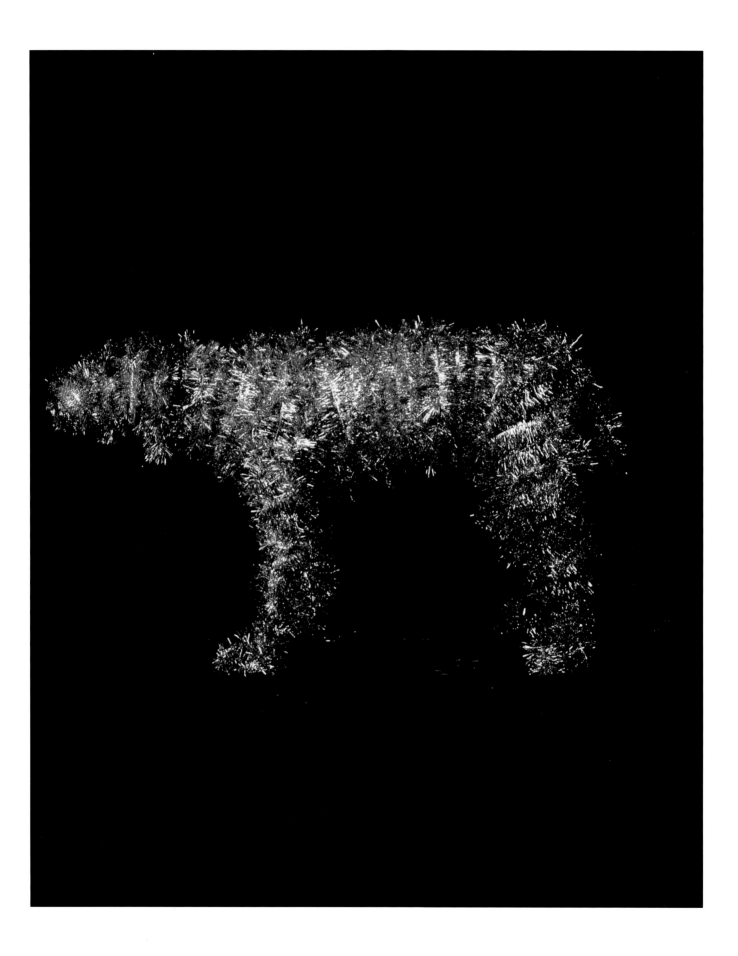

AIREDALE #1 STANDING. 1981. The Corcoran Gallery of Art, Washington, D.C.

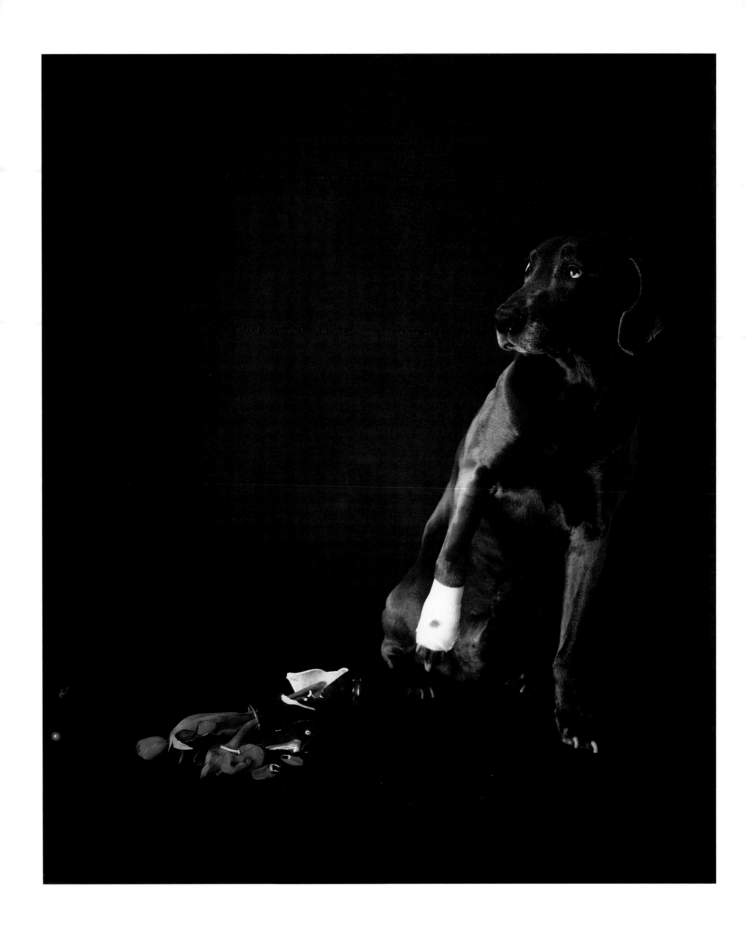

BROKEN HURT. 1981. Collection William J. Hokin

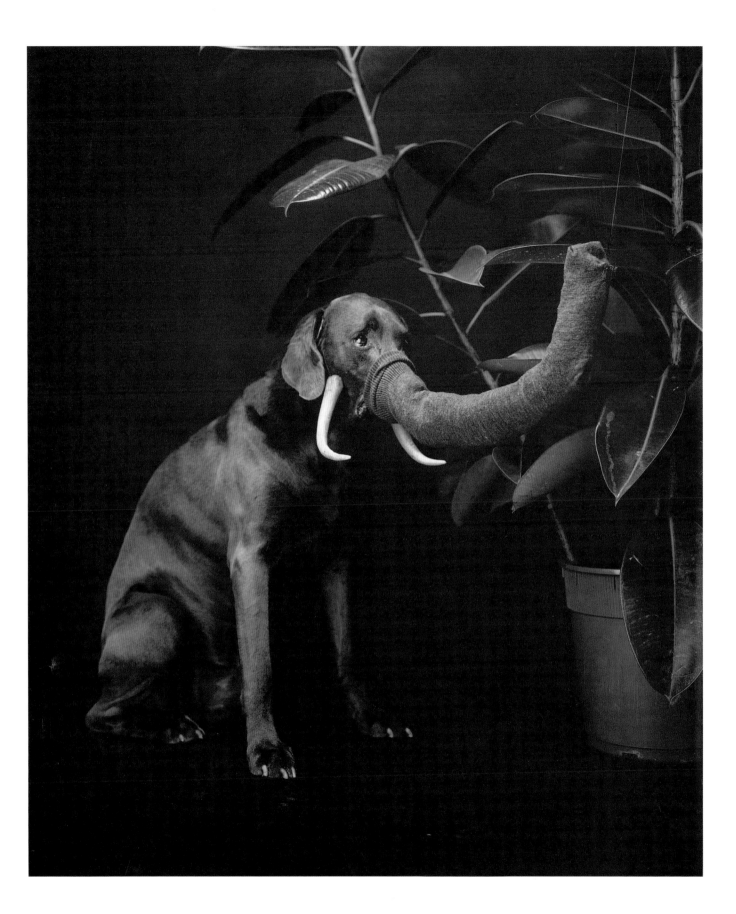

ELEPHANT. 1981. Courtesy Fraenkel Gallery, San Francisco

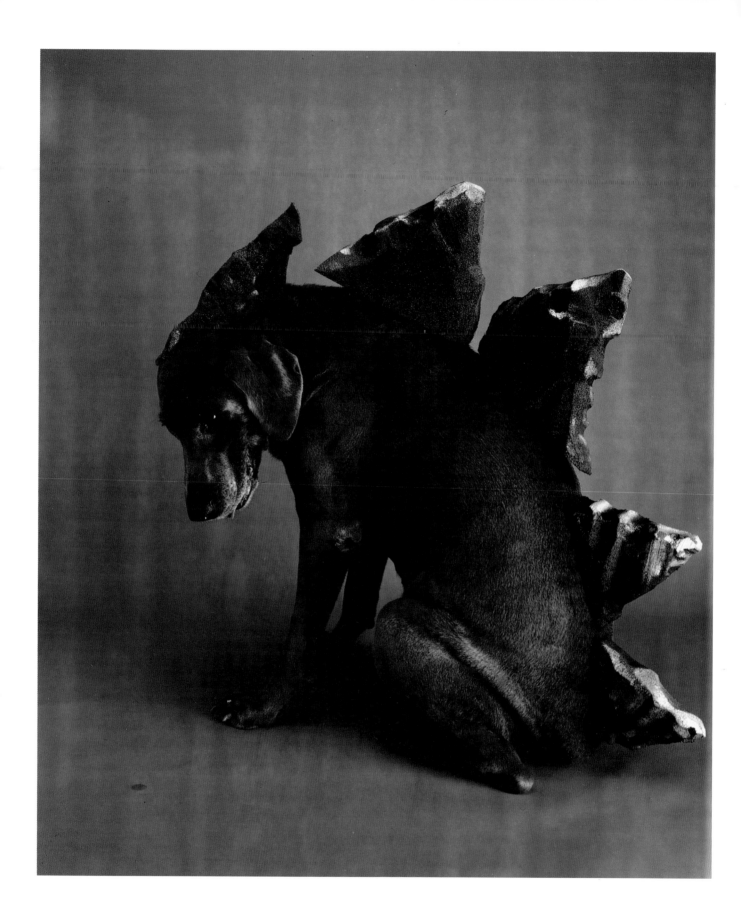

DINO RAY. 1981. Collection William J. Hokin

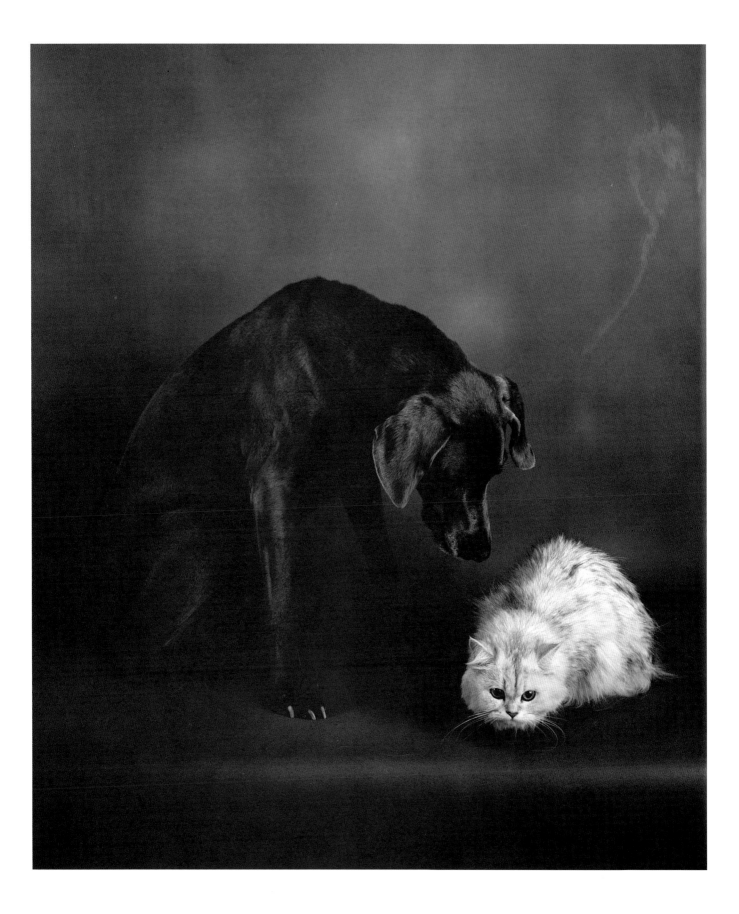

RAIN. 1981. Collection BankAmerica Corporation, San Francisco

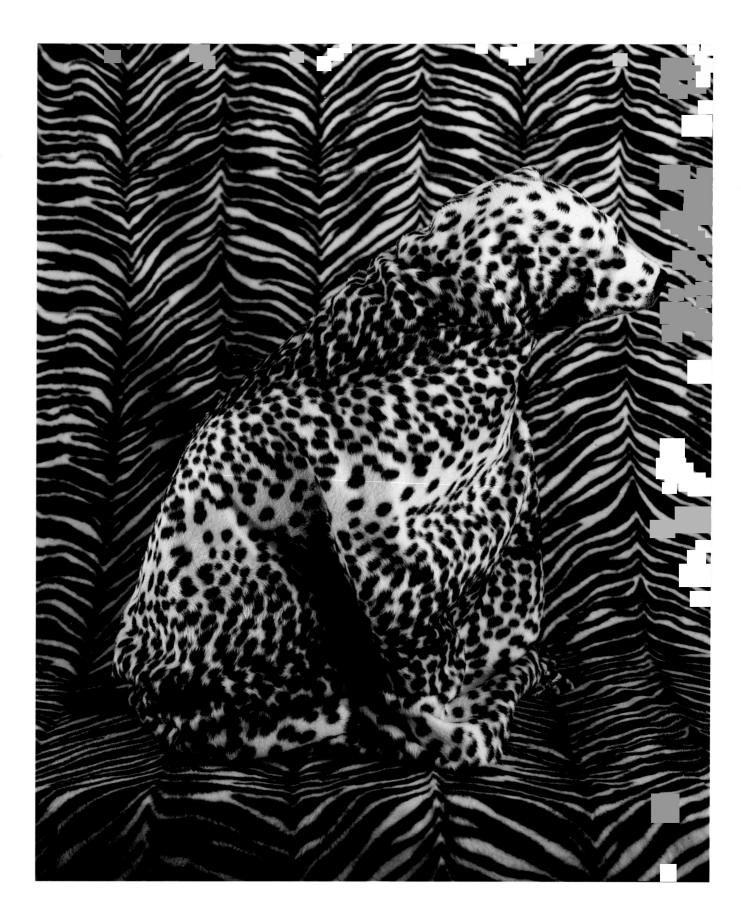

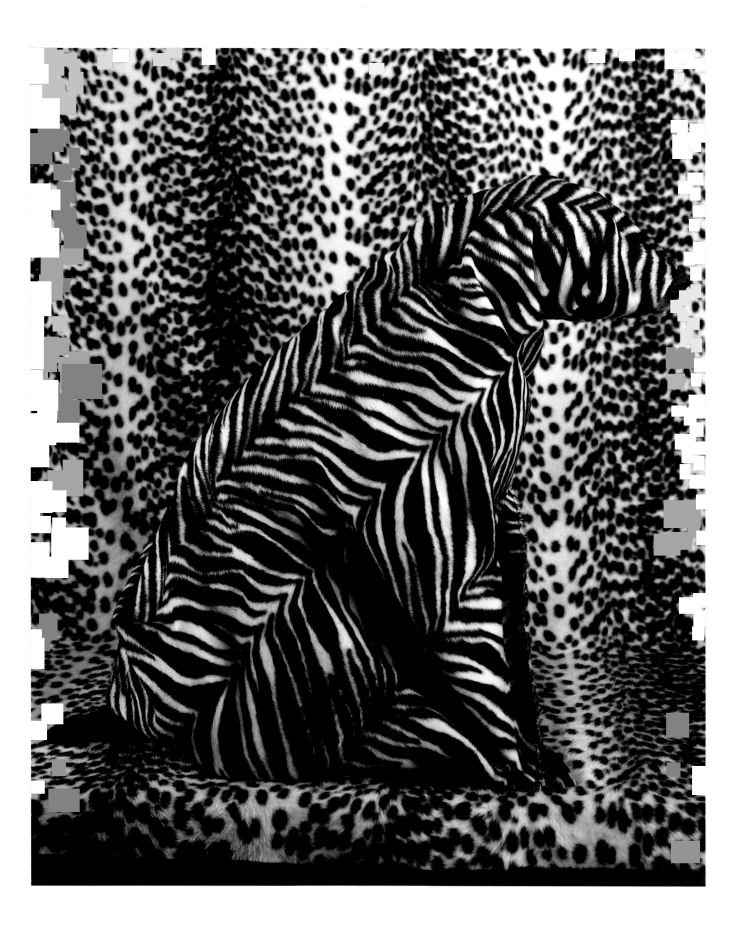

LEOPARD/ZEBRA. 1981. Collection Sherry and Alan Koppel

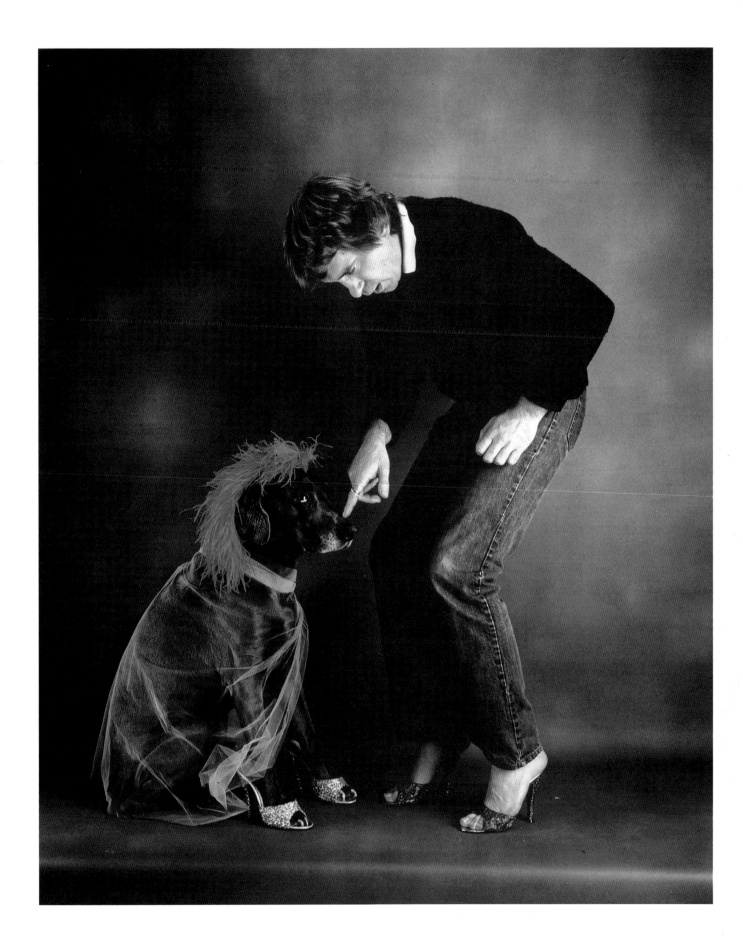

HEELS. 1981. Collection Gifford Myers, California

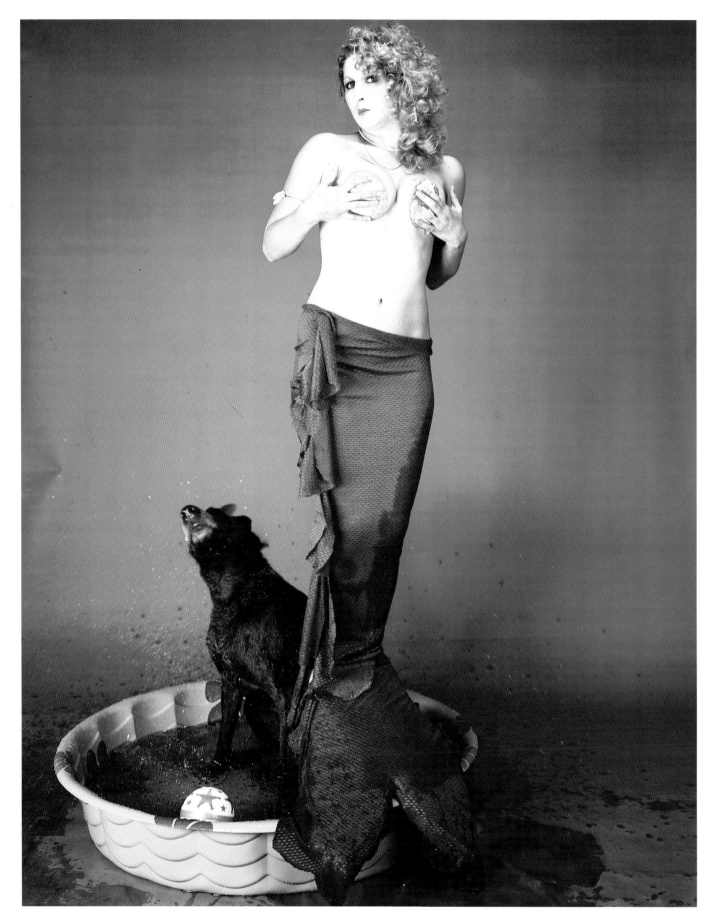

UNTITLED (MERMAID). 1980. Courtesy Holly Solomon Gallery, New York
With Hester Laddy

BAD DOG. 1981. Brooklyn Museum

RAY & MRS. LUBNER IN BED WATCHING TV. 1981. Collection Mr. and Mrs. Thomas K. Ireland, Florida

BLUE PERIOD. 1981. Collection Anita Grossman, New York

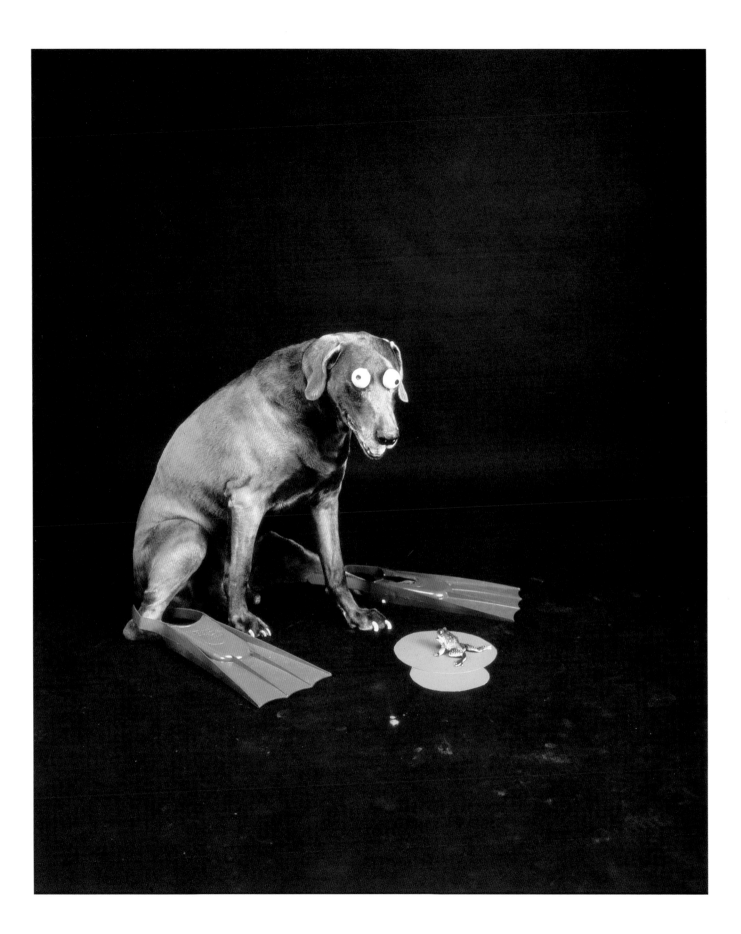

FROG/FROG II. 1982. Collection Helen Lewis Meyer

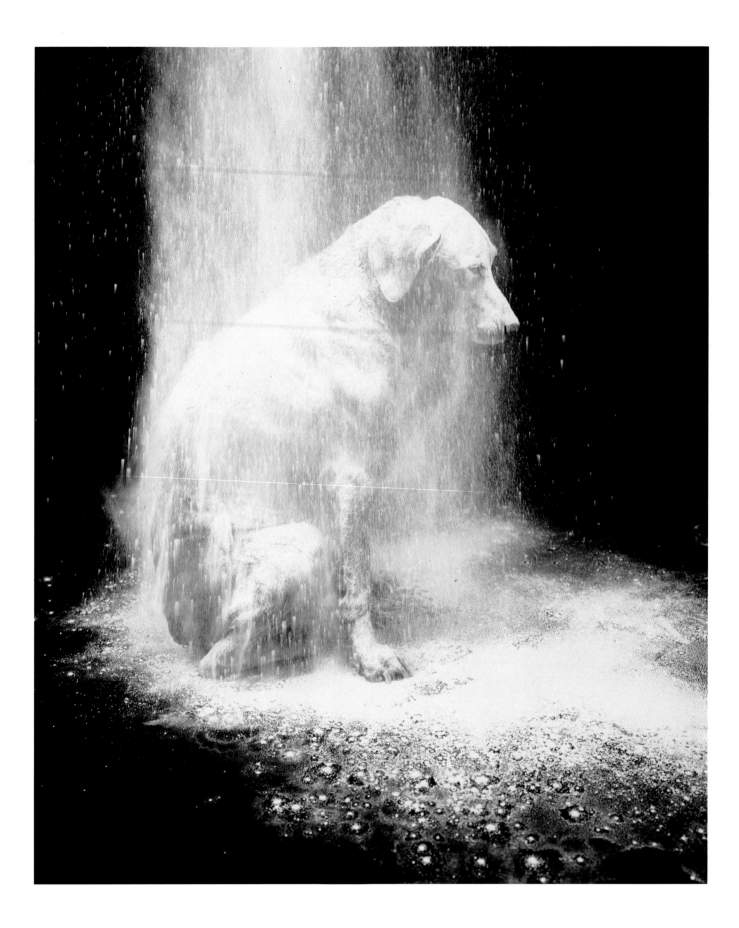

DUSTED. 1982. Collection Gifford Myers, California

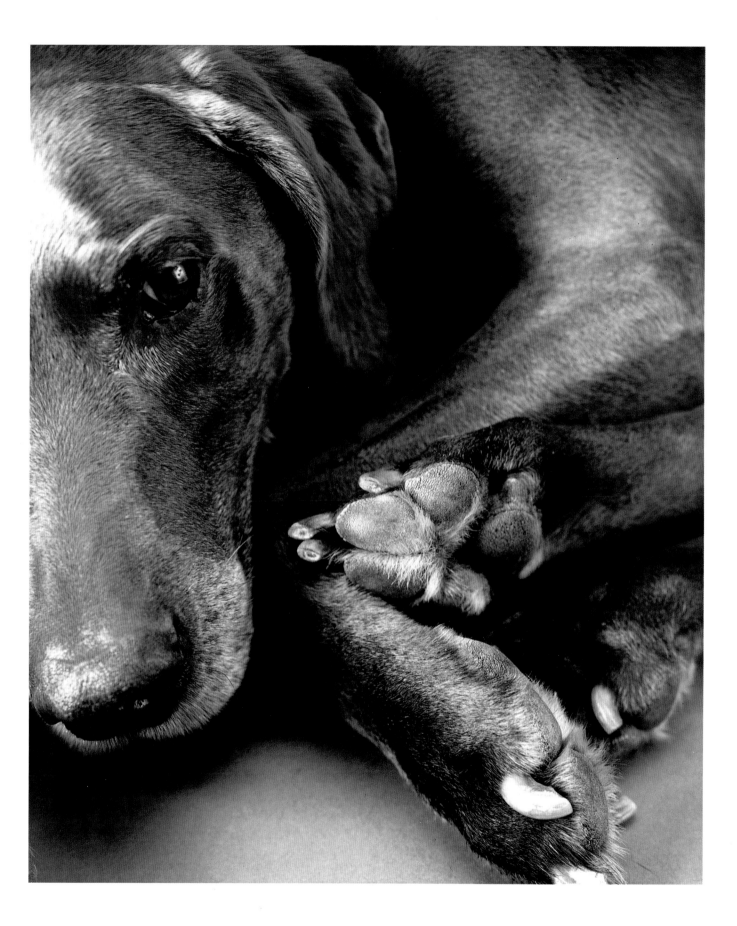

ROUGE. 1982. Collection the Artist

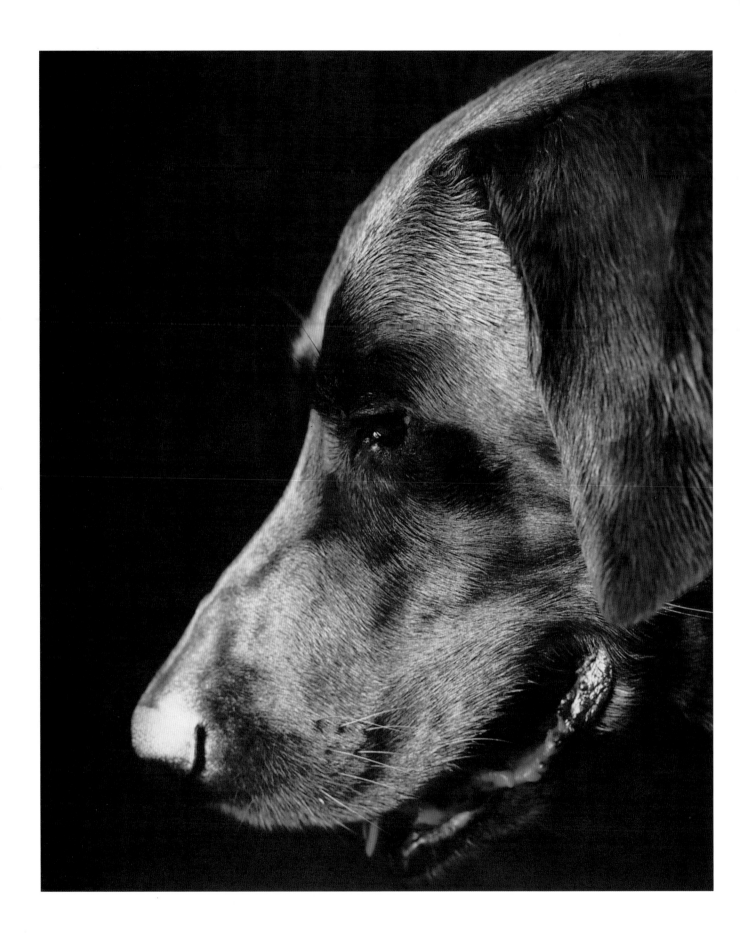

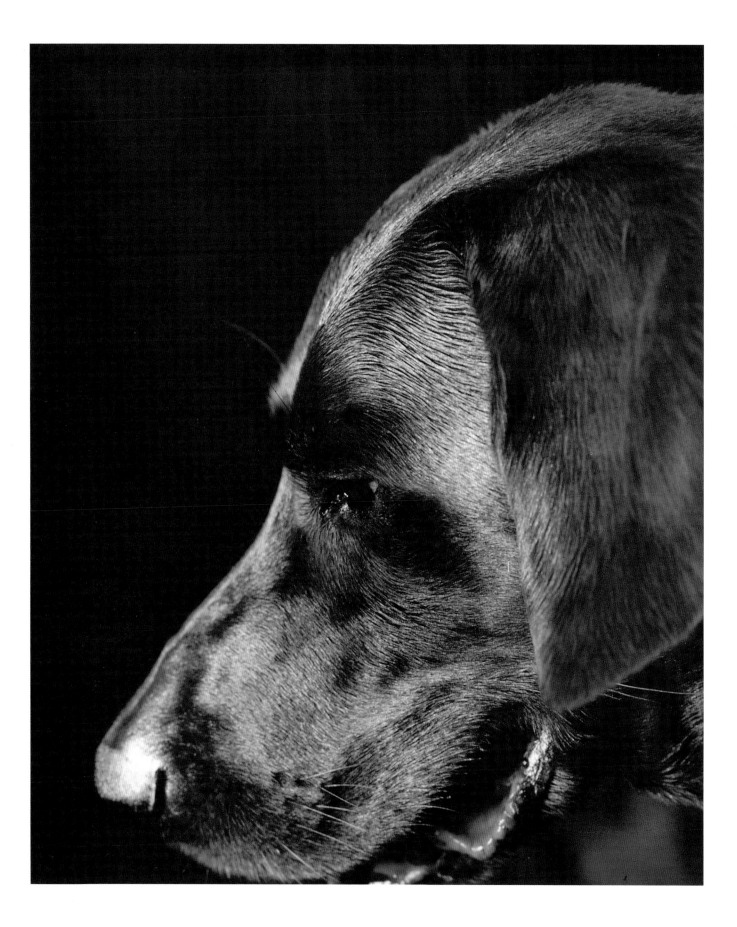

SILVER AND GOLD. 1982. Courtesy Holly Solomon Gallery, New York

FOSTER PARENTS. 1984. Courtesy Holly Solomon Gallery, New York

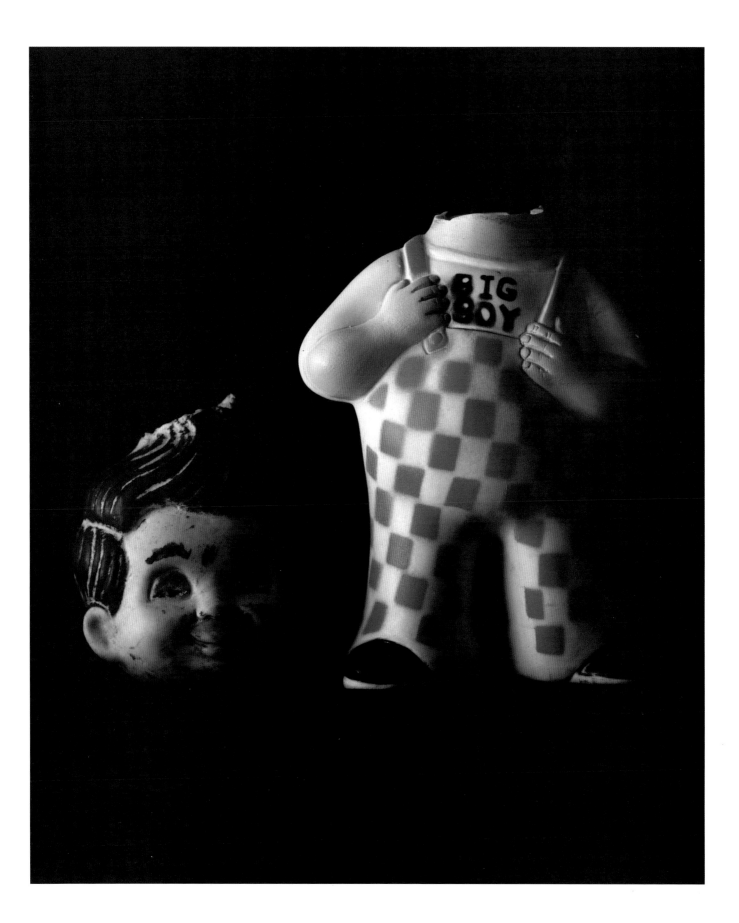

BRING ME THE HEAD OF BIG BOY. 1981. Courtesy Holly Solomon Gallery, New York

EAU II. 1983. Courtesy Holly Solomon Gallery, New York

FOAMY AFTER-SHAVE. 1982. Courtesy Holly Solomon Gallery, New York

HANDY. 1984. Collection Mr. and Mrs. Jerry Spiegel, Florida

CARAVAGGIO. 1983. Courtesy Holly Solomon Gallery, New York
With Eve Darcy

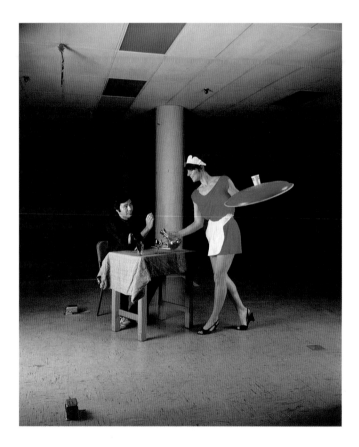

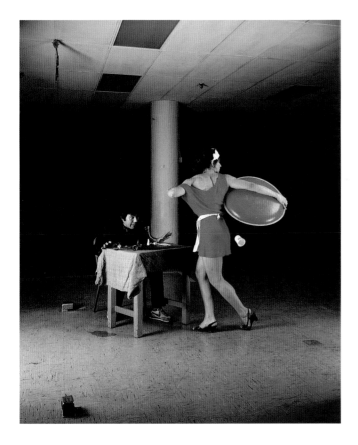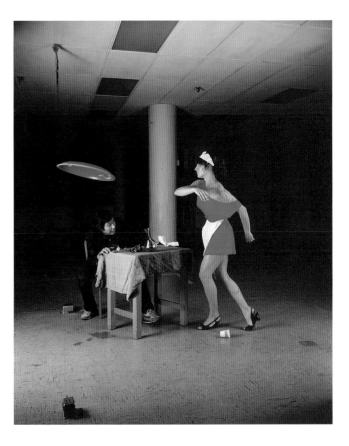

GREEK RESTAURANT. 1982. Newport Harbor Art Museum, California. Anonymous Doner
With Eve Darcy and John Reuter

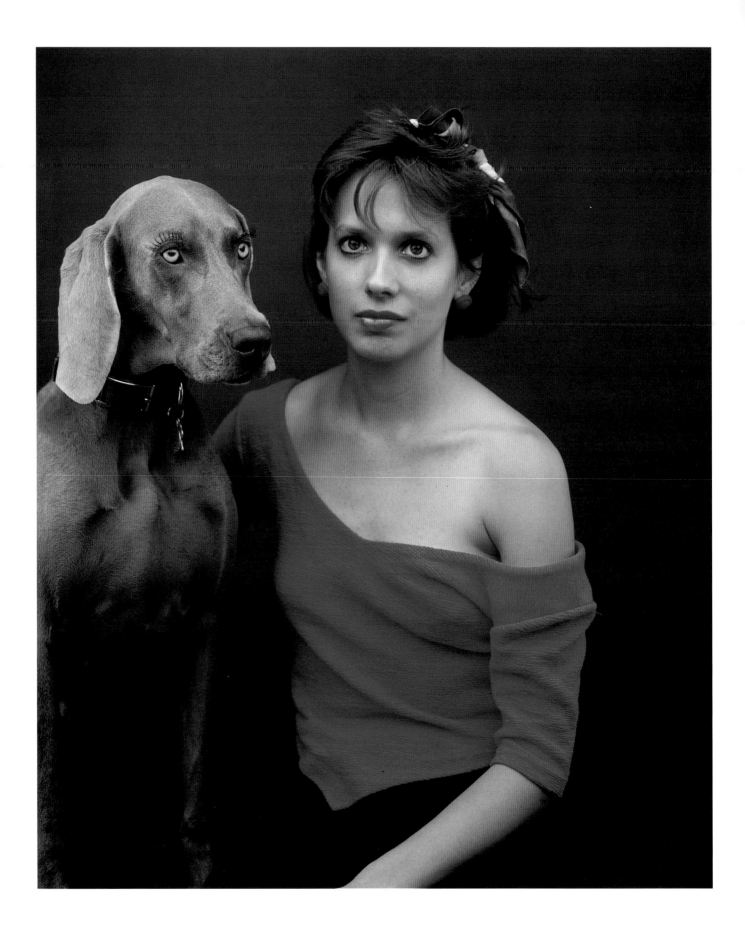

FAY AND ANDREA. 1987. Collection Gayle Greenhill, Connecticut
With Andrea Beeman

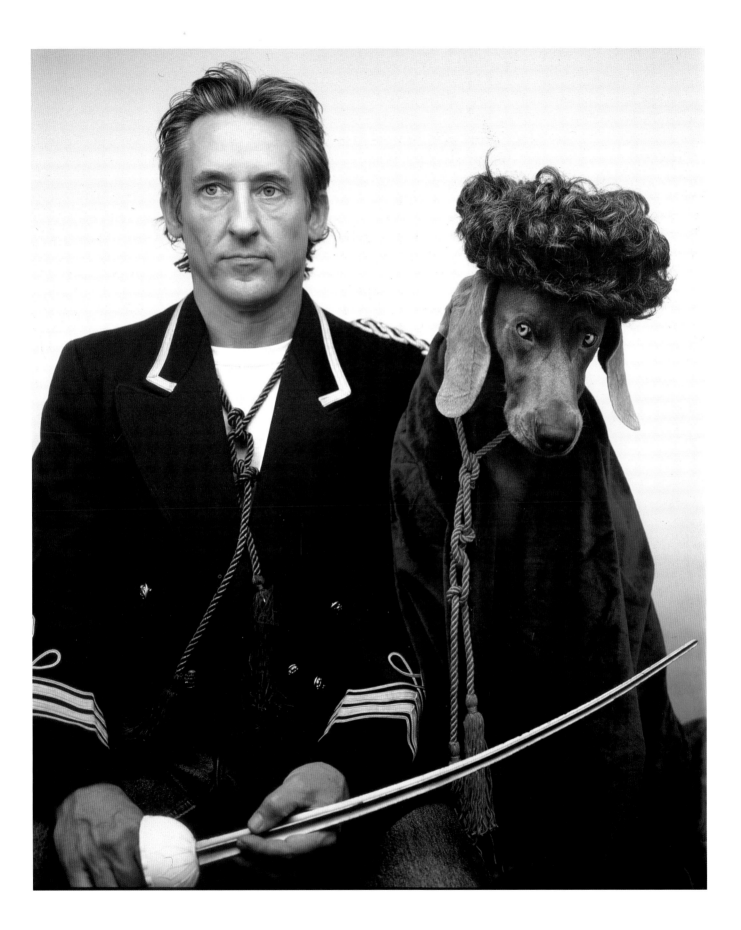

SWORDED. 1987. Collection George Dalsheimer, Baltimore
With Ed Ruscha

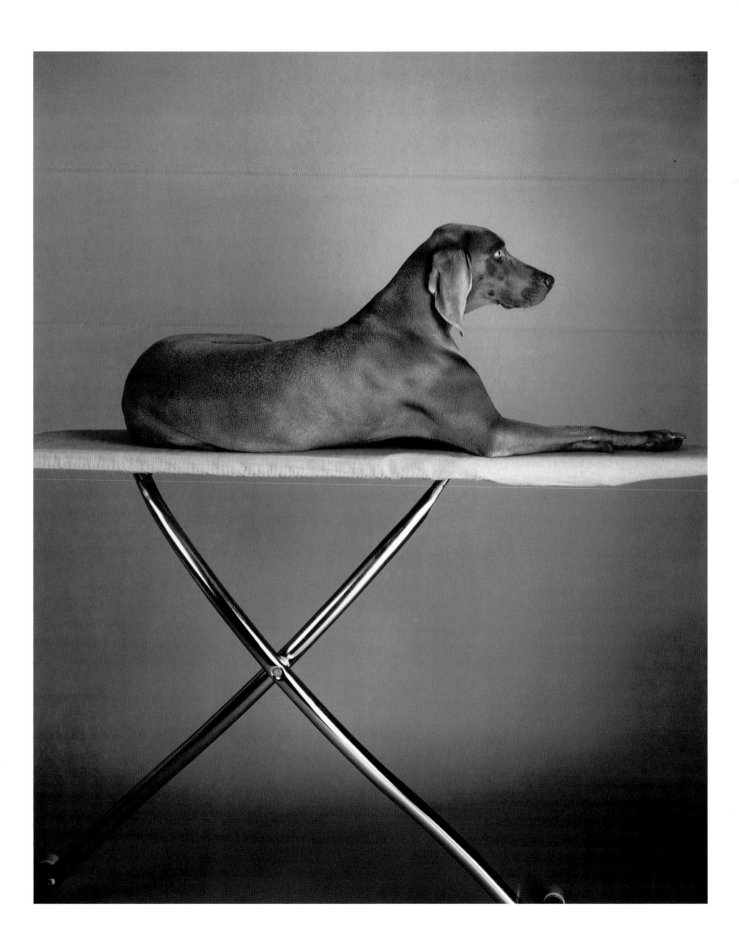

FAY ON BOARD. 1987. Collection Sandy Fellman, New York

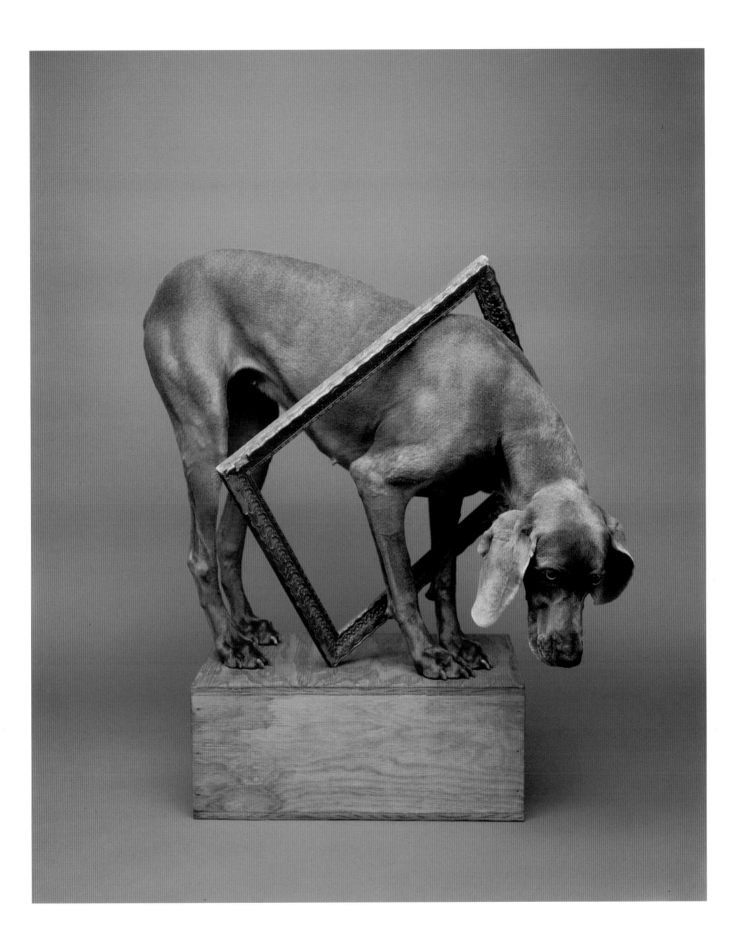

BOXED/FRAMED. 1988. Courtesy Pace/MacGill Gallery, New York

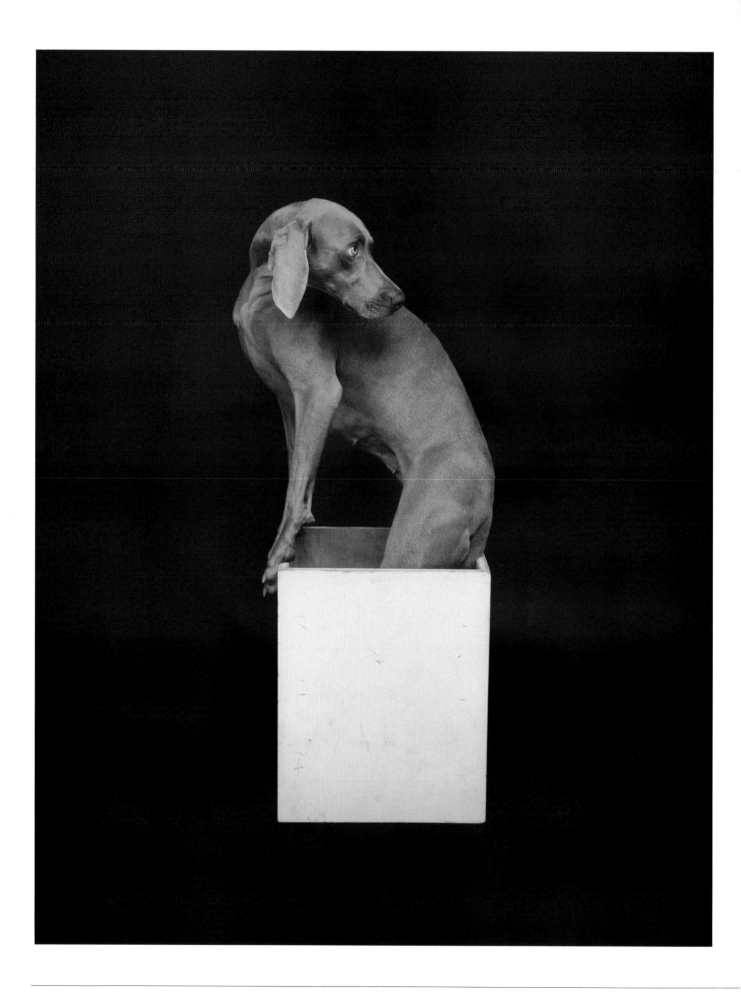

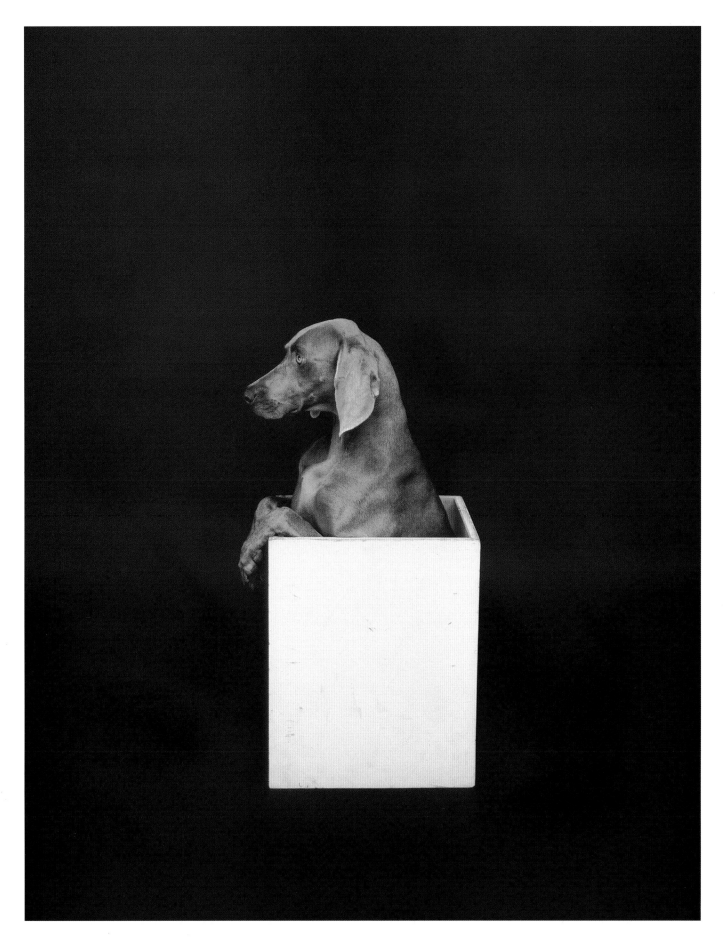

IN THE BOX. 1987. Collection Ruth Silverman

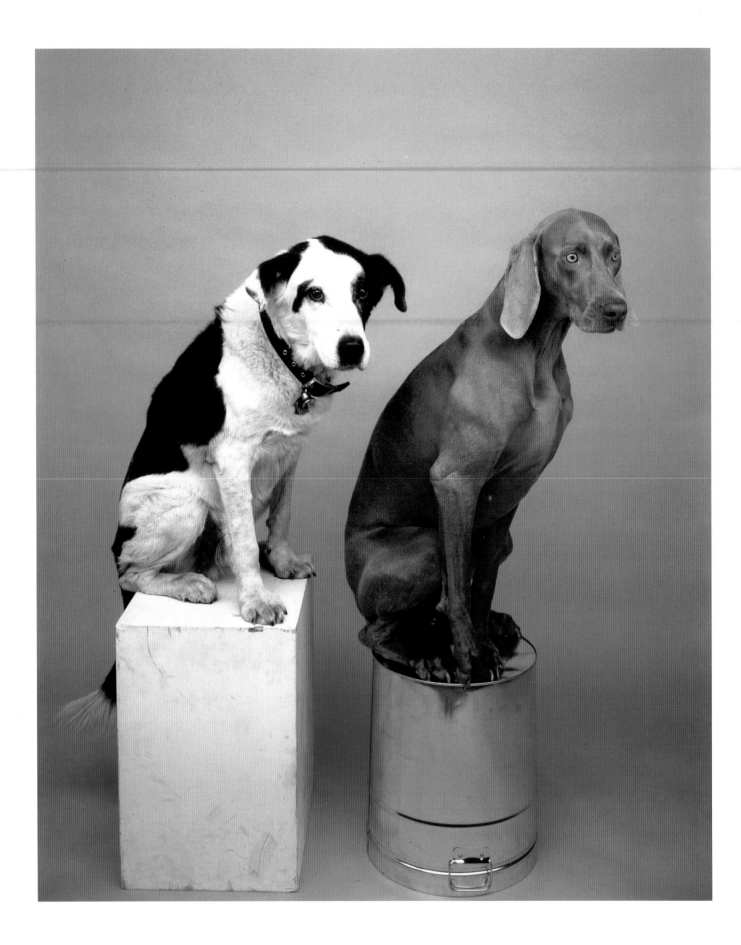

TAME ANIMALS. 1987. Collection George Dalsheimer, Baltimore

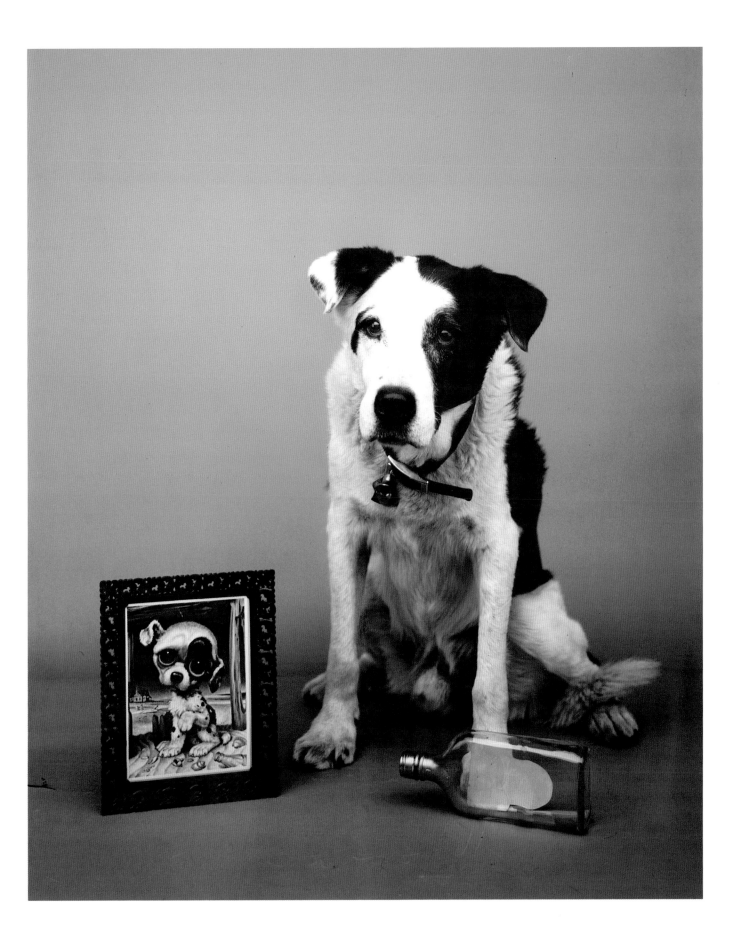

CHARLIE. 1987. Courtesy Pace/MacGill Gallery, New York

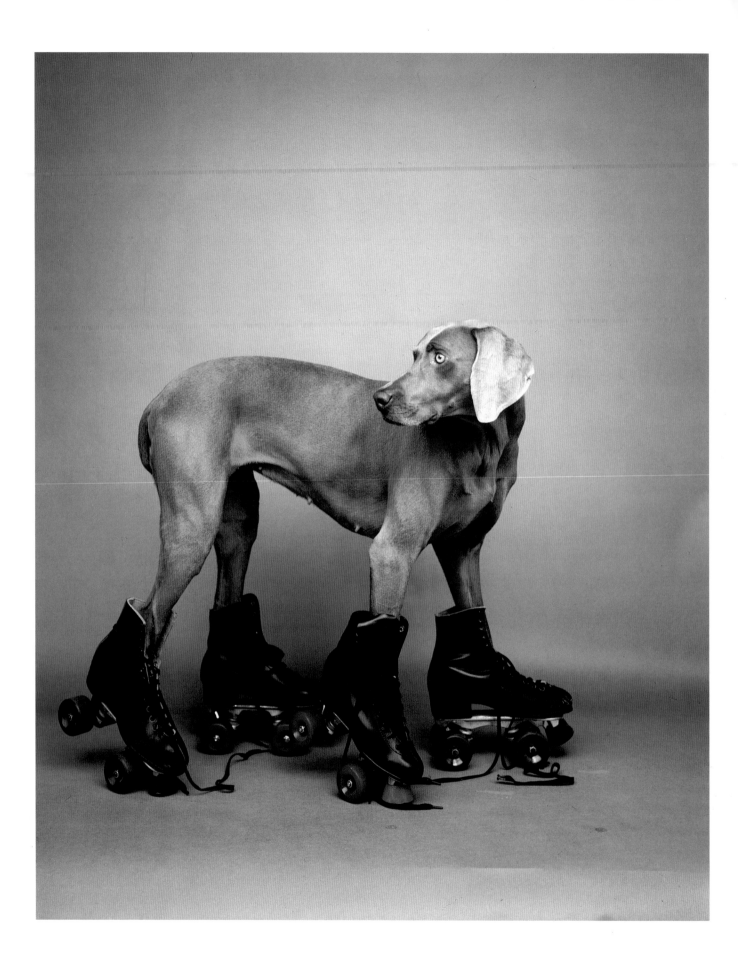

ROLLER ROVER. 1987. Collection Judd Burnstein, New York

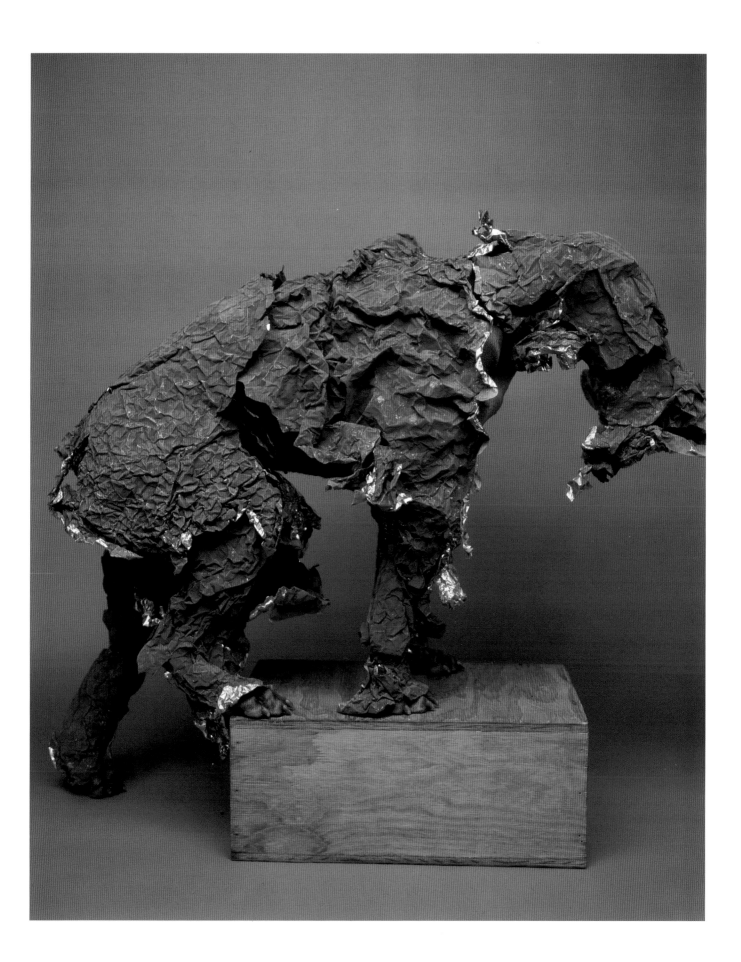

EARLY DOG. 1987. Courtesy Pace/MacGill Gallery, New York

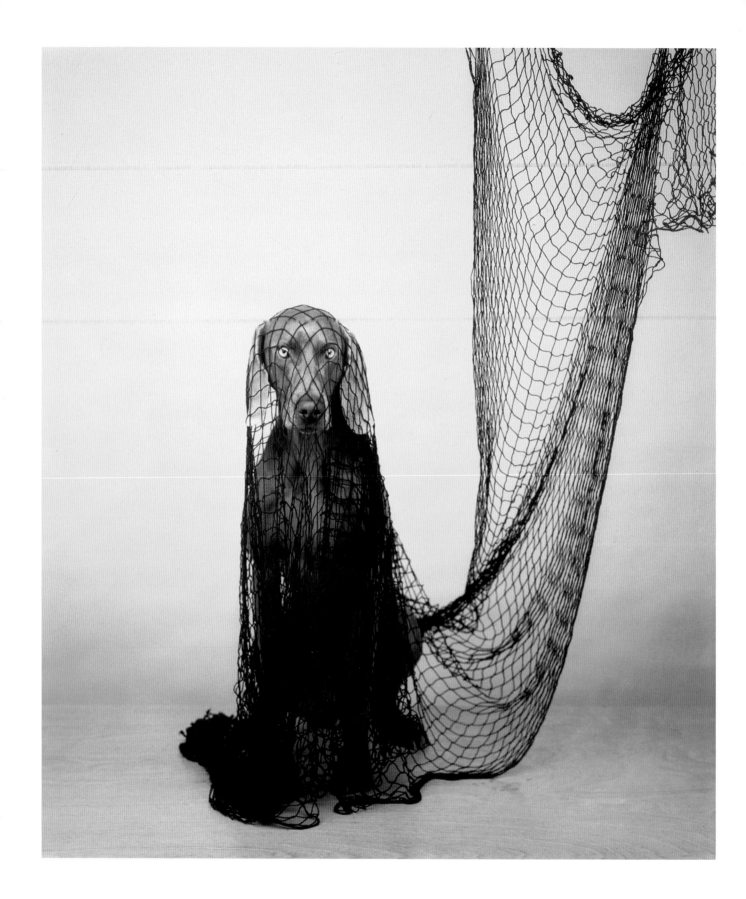

NETTED. 1987. Collection the Artist

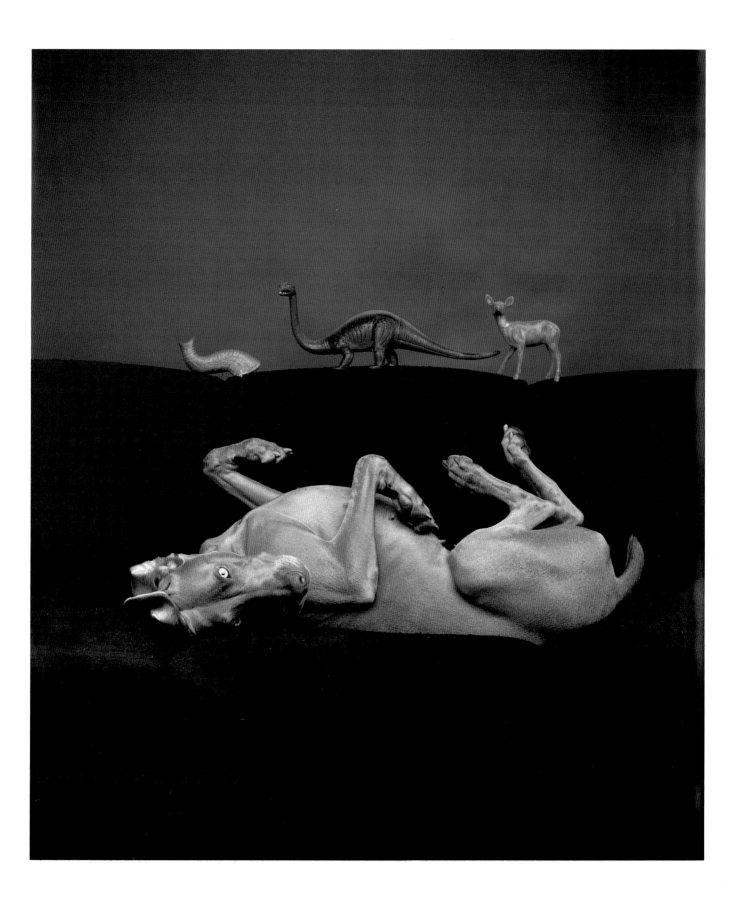

EVOLUTIONARY. 1987. Collection Mr. and Mrs. Richard Barnett, Ohio

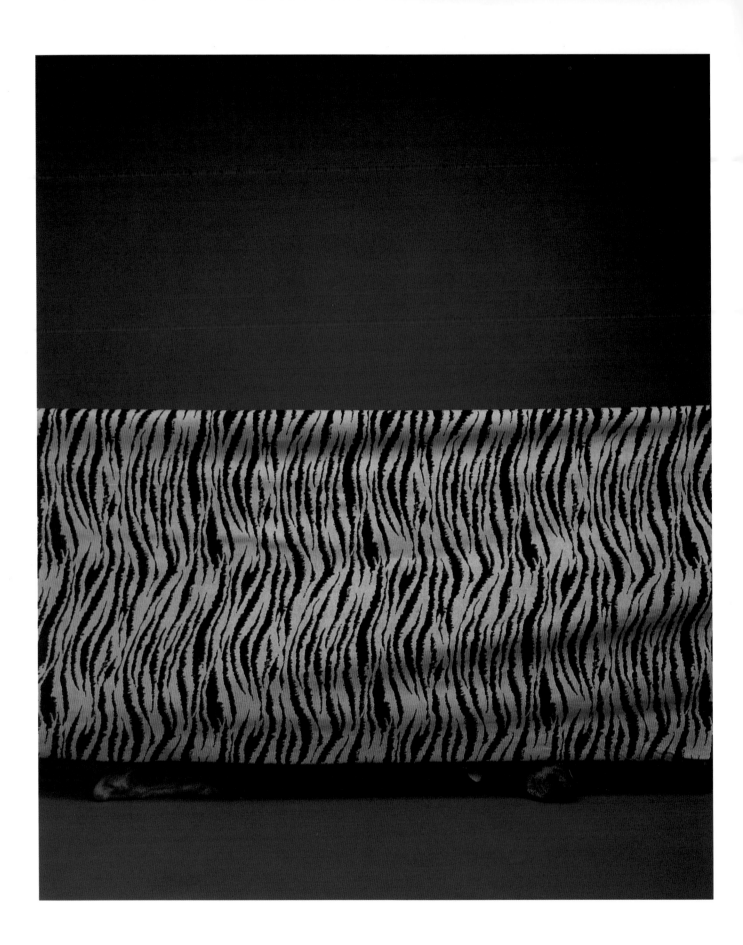

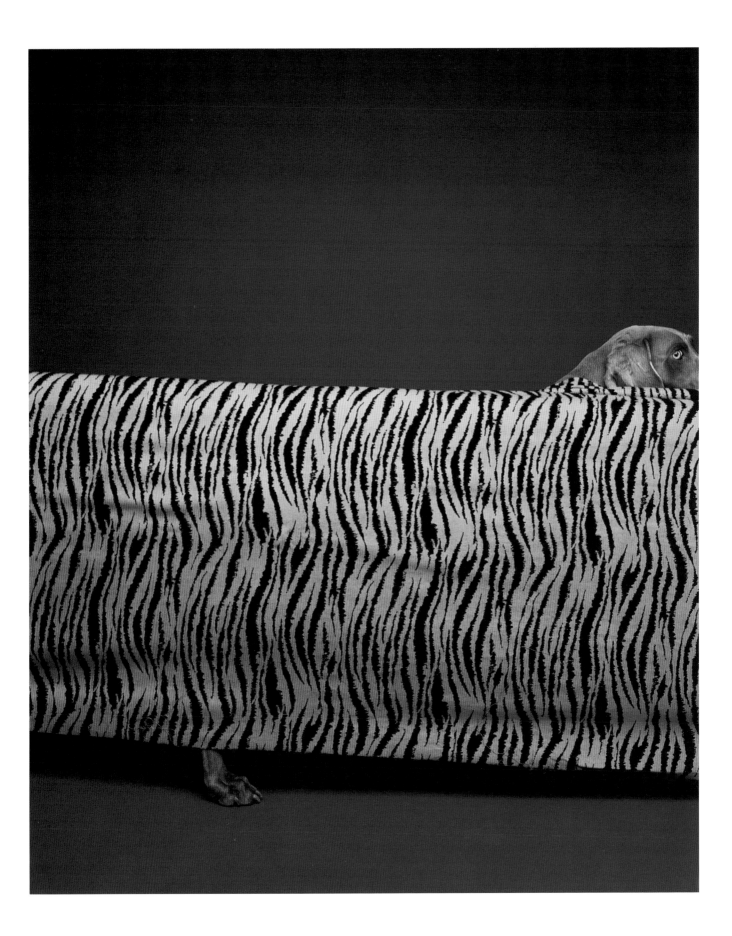

NAMBIAN TRAIN. 1988. Courtesy Pace/MacGill Gallery, New York

SLEEPING/PRAYING. 1988. Courtesy Pace/MacGill Gallery, New York

TORPEDO/ARMED. 1988. Private Collection, New York

MATTED. 1988. Courtesy Pace/MacGill Gallery, New York

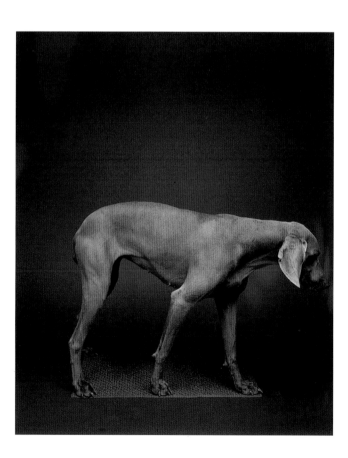

FRONT/SIDE. 1988. Courtesy Pace/MacGill Gallery, New York

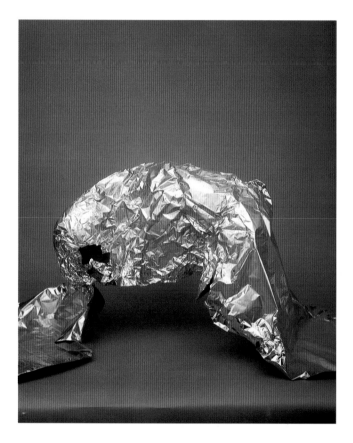 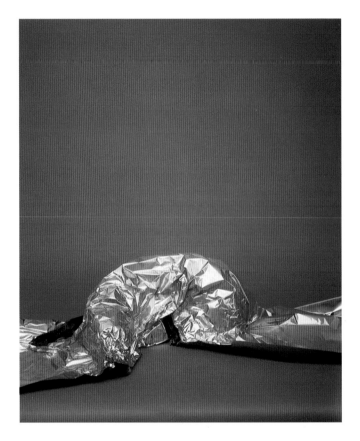

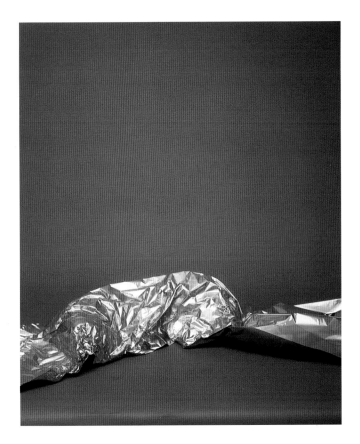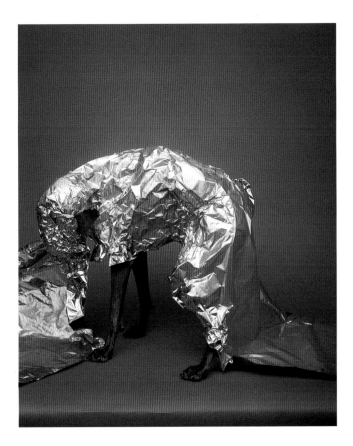

METALIZED. 1988. Courtesy Pace/MacGill Gallery, New York

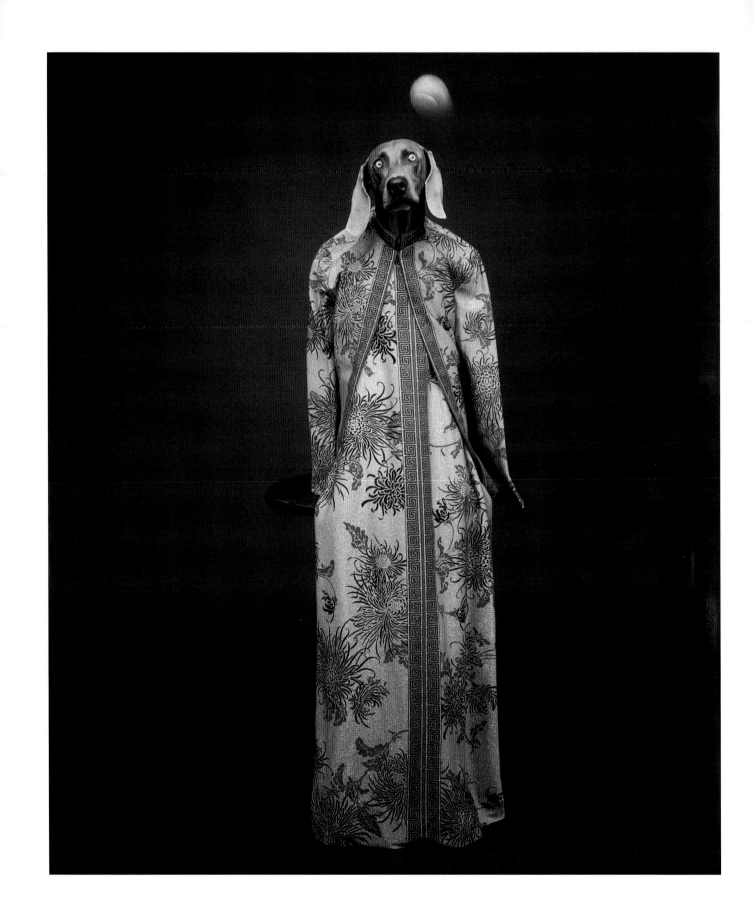

DRESSED FOR BALL. 1988. Victoria & Albert Museum, London

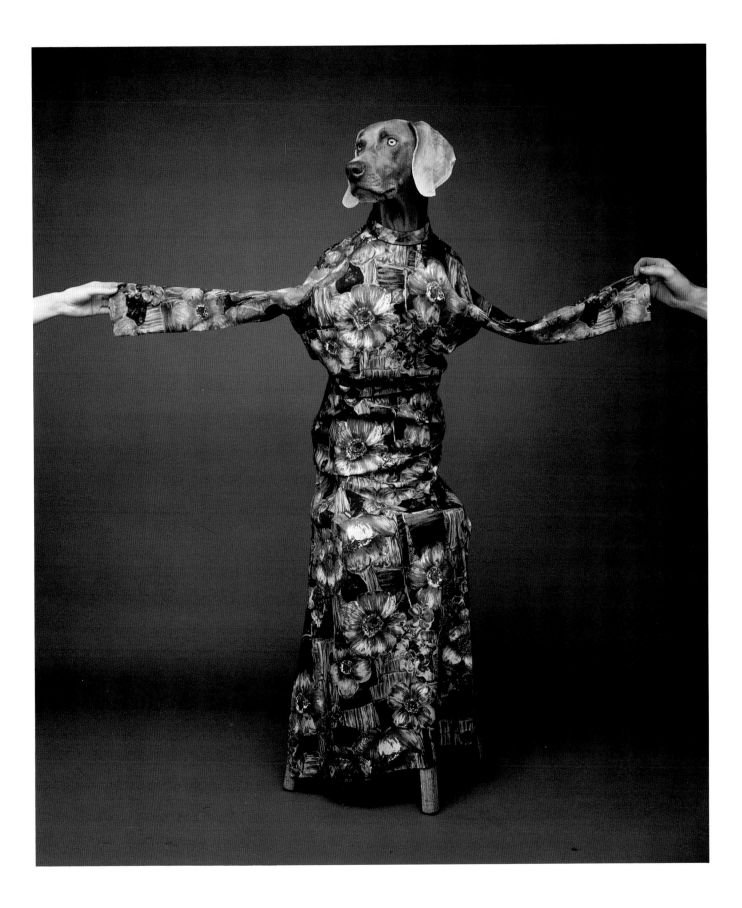

THREE LEGGED DANCE. 1988. Courtesy Pace/MacGill Gallery, New York

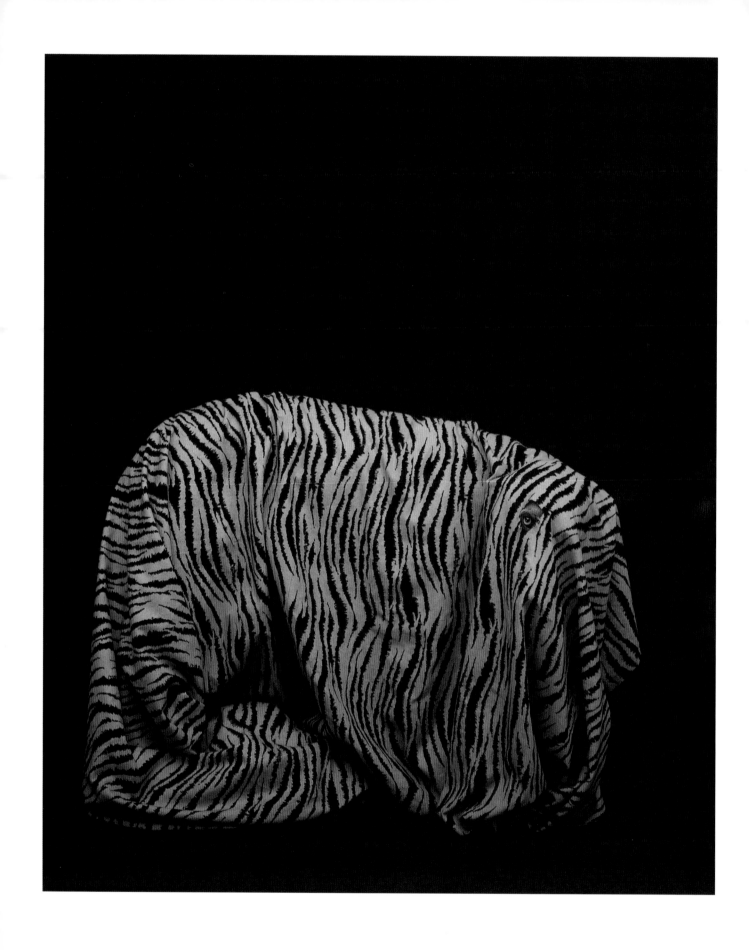

GUISE. 1988. Courtesy Pace/MacGill Gallery, New York

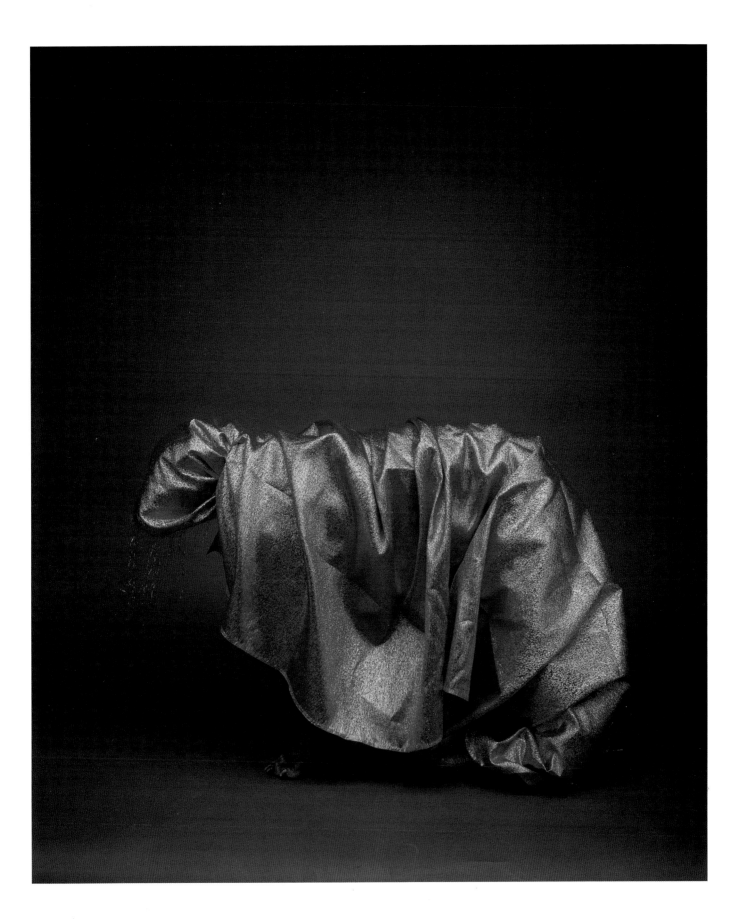

RENAISSANCE WORM. 1988. Courtesy Pace/MacGill Gallery, New York

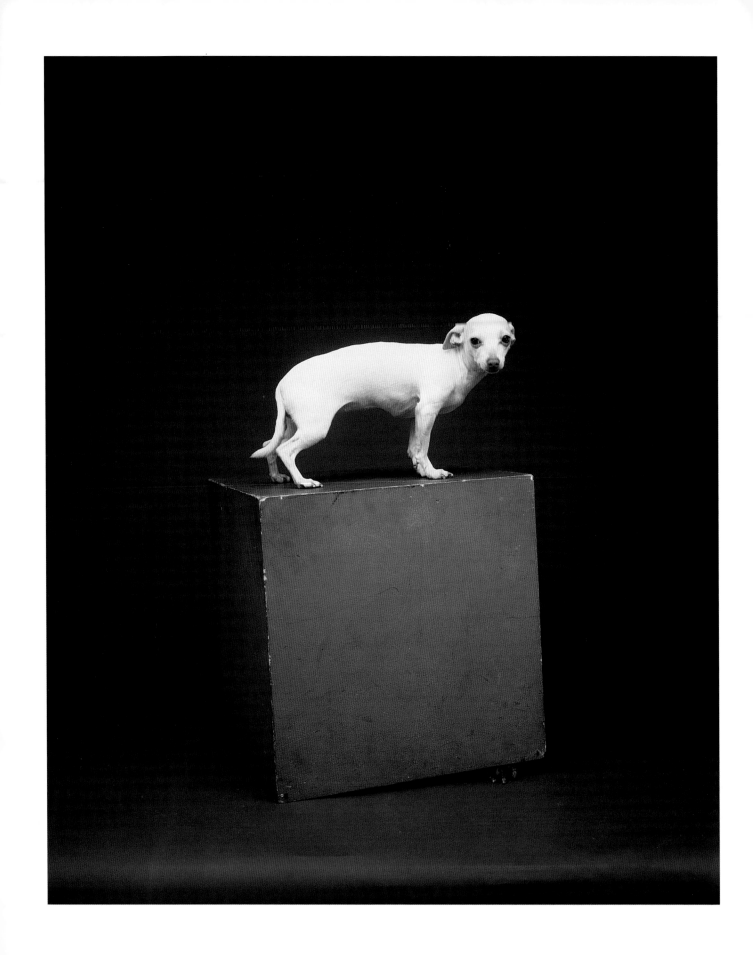

CORNER PIECE. 1989. Courtesy Pace/MacGill Gallery, New York

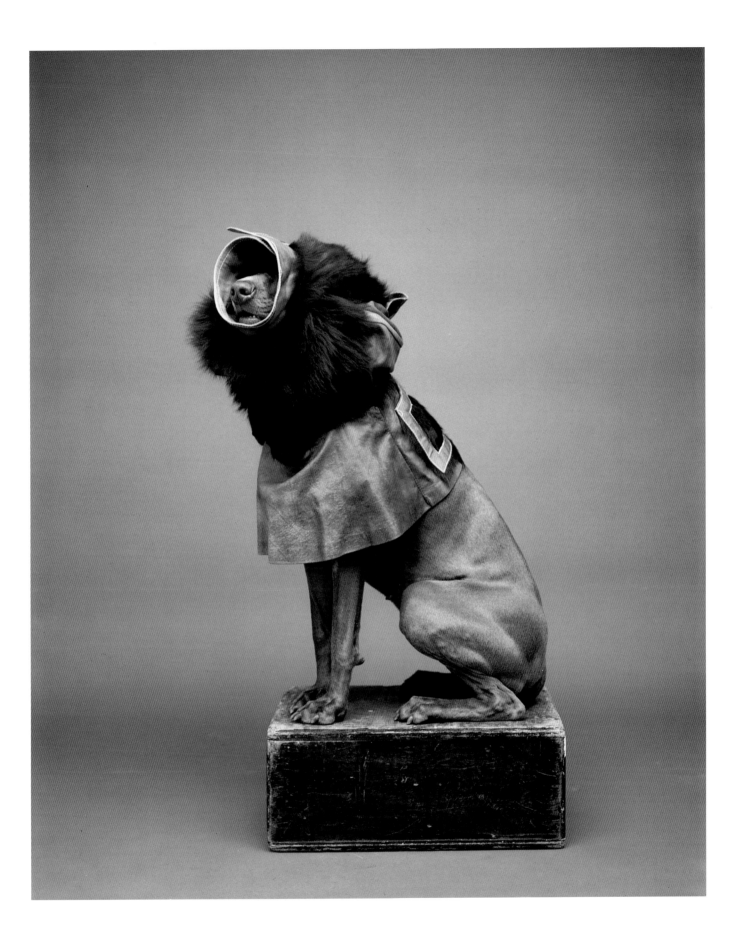

COAT HOG. 1988. Collection Daniel Hechter, Paris

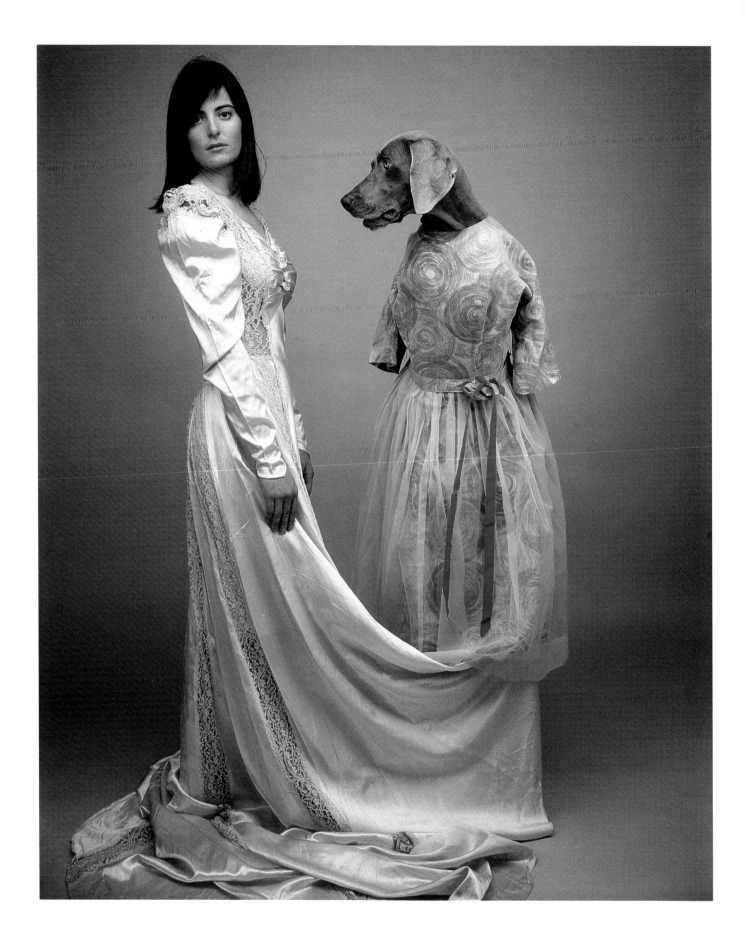

ARM ENVY. 1989. Collection Gilles Fuchs, Paris
With Alexandra Edwards

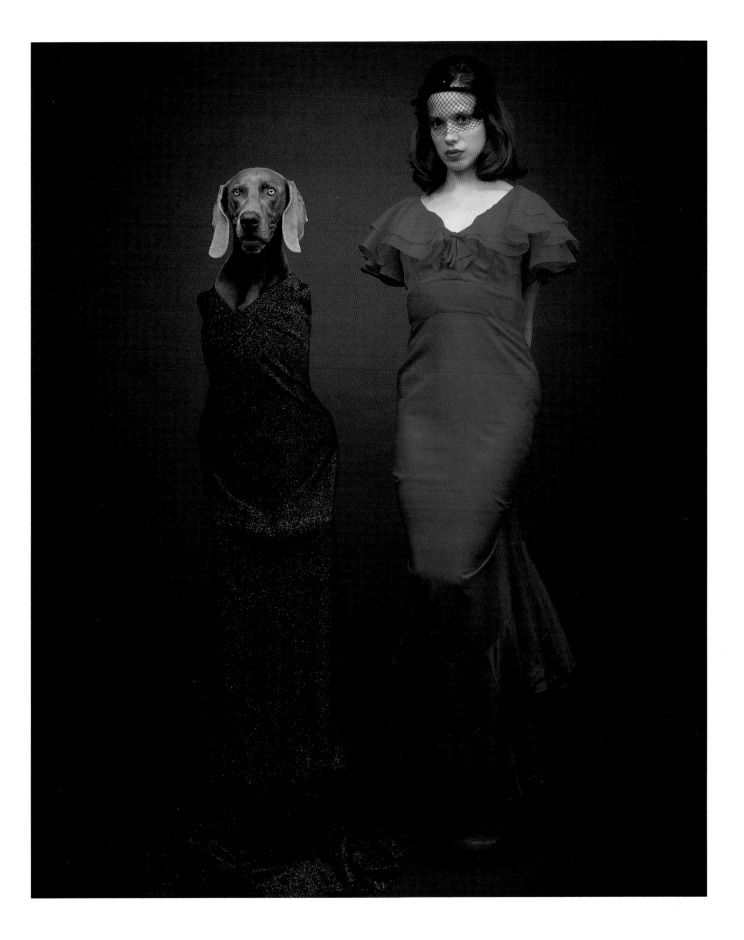

MODELS. 1989. Collection Leonard Rosenberg, New York
With Andrea Beeman

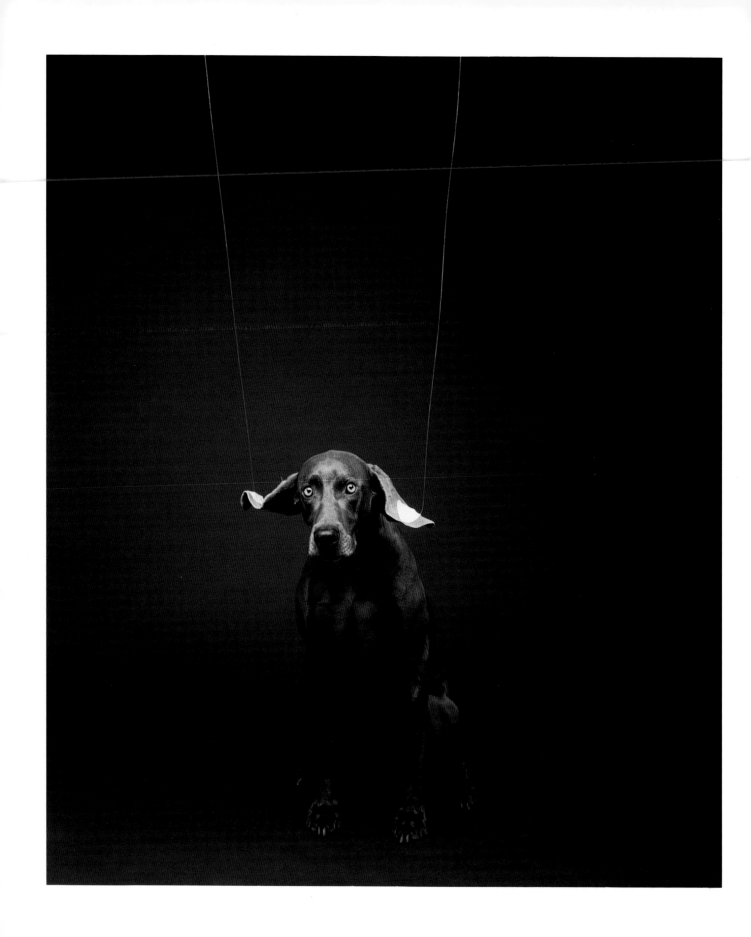

FAY AND MARIONETTE. 1989. Courtesy Pace/MacGill Gallery, New York

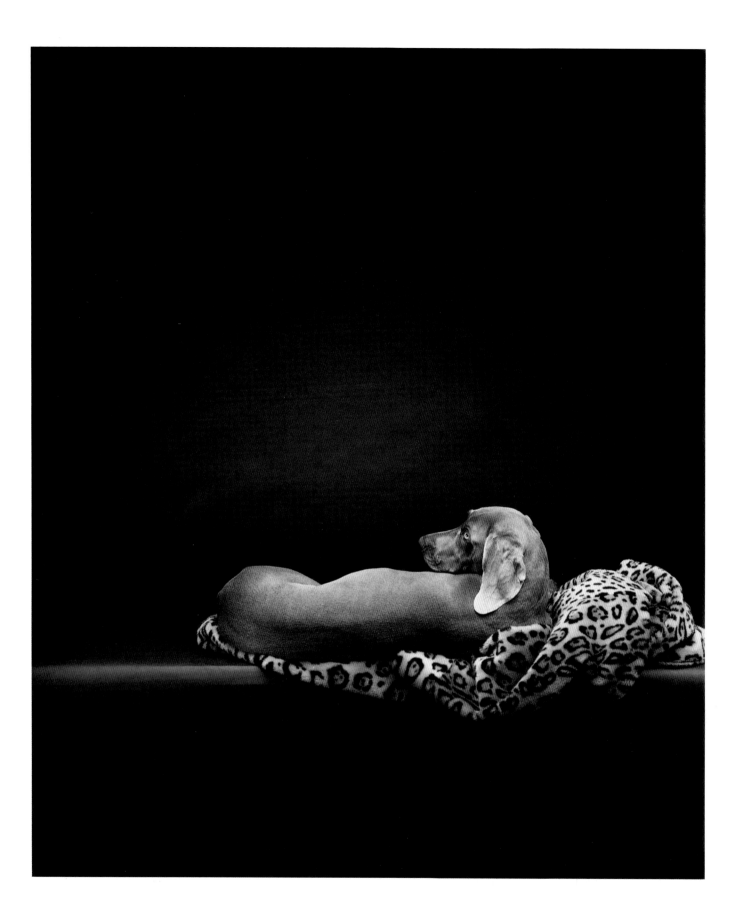

LE DOUANIER FAY. 1989. Collection Polly Anthony, New York

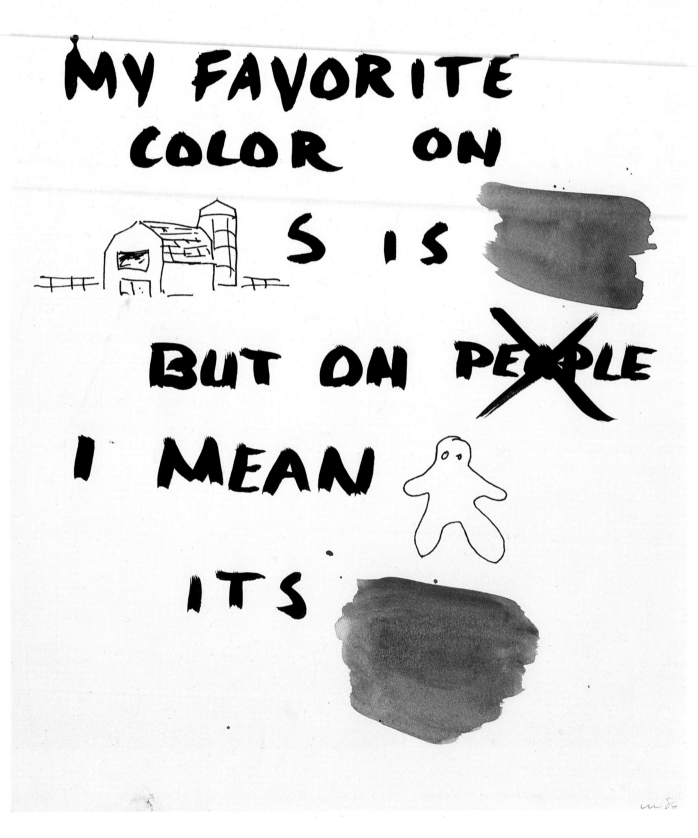

MY FAVORITE COLOR ON ▢S IS ▬ BUT ON PEⓍPLE I MEAN 🙂 ITS ▬

FAVORITE COLOR. 1980. Ink and watercolor on paper, 11 × 14″. Collection the Artist

MARTIN KUNZ

Drawings: Conceptual Pivot of Wegman's Artistic Worlds

Before William Wegman started making drawings in 1972 as an independent medium, he had worked primarily with black-and-white photography and video. His drawing consisted only of plans and sketches for his spatial installations, or stage directions for his videos. Even the latter are rare, however, because he usually did little more than write a brief script, which was elaborated and often adapted in the process of shooting.

Words are vital and sometimes dominant in Wegman's art, and not only as captions for images or voice-over narration in videos; they also figure actively in thoughtfully conceived photographs, pictures, or drawings. Sometimes Wegman will cite words in his pictures; sometimes words ARE the picture. Wegman never thought of his early sketches as artworks; he calls them "doodles." Not until 1972 did he begin making drawings as drawings, although these are hardly more elaborate or easier to decipher than are the doodles. They are, in fact, so reduced as to be almost minimalist. A few scant lines serve to define some usually banal pictorial content.

A series of handwritten E's and L's titled 16 E'S 16 L'S (1973; page 146) is a drawing that he considers typical of his early work. The E's and L's, written in lower case, are deceptively similar. At first sight, they appear to be five lines of L's alone, some larger, some smaller, casually scrawled across the page like a child's exercise in handwriting. A school assignment and not a drawing worthy of artistic interpretation? If both content and execution are patently banal, the "artistry" of the work must lie—if at all—in its conceptual, mental setting. The idea is not new to modernity, especially since the advent of Conceptual Art, except that the tautological approach of Conceptual Art, in which the work defines a quality inherent in the work itself, establishes it implicitly and explicitly as art. A plain idea executed with simple craftsmanship is presented as an artistic manifesto: the word "BLUE" handwritten in blue, for example, or a purely verbal proposition like Joseph Kosuth's statement, "the definition of art is art," or an emblematic definition of a pictorial form, abstract or figurative, which should by rights be executed in another material or dimension.

Contrary to the conceptual approach, Wegman chooses not to make the artistic statement of his banal drawings explicit. It is, in fact, completely concealed; he has no scruples about the somewhat naive, silly impression conveyed by his uncompromisingly consistent banality. He acts as if he does not even know what statement he wants to make. He advances a kind of anti-statement, especially in the exaggerated conventionality of his means. Not for him the avant-garde forms and vehicles of neon tubing, photograph, object, or written sign, used, for instance, by Kosuth for his propositions. Wegman, trivial as he may be, obviously assumes that we are all aware of the existence of Conceptual Art; that therefore his title, 16 E'S 16 L'S, defines the subject matter of the picture.

The mundane triviality of Wegman's works would overshadow their ironic and cynical wit if they were not placed an art context. In many ways Wegman's approach recalls the wit and method of Marcel Duchamp's ready-mades, especially those that manipulate popular art, such as PHARMACY (1914), a cheap art reproduction of a winter landscape that Duchamp altered by adding three green dots and three red dots, recalling miniscule figures in the distance as well as lights seen from a moving train. When Duchamp started transforming ordinary objects, even popular art, he took the art world by surprise.

Apart from his closest friends, viewers, unaware of his intent, overlooked the artistic statement and status of his objects even when they were displayed in the context of a museum or gallery. The first time Duchamp showed his ready-mades, people simply didn't see them. At the Armory Show in New York in 1917 where he exhibited his urinal, FOUNTAIN, under the pseudonym of R. Mutt, he had to call the public's and even the critics' attention to the presence of his work—much to his roguish delight. Years later, by which time his method had become more familiar, he took pleasure in recalling how people simply sailed in, oblivious to the objects he had put up in the entrance hall of the Bourgeois Gallery in 1916. I think Wegman takes a similar delight in claiming artistic status for seemingly banal, ordinary things. But, unlike Duchamp (who also selected objects on the basis of their "artless ambivalence"), Wegman's things are not objects but rather banal pictorial IDEAS that derive from the mass media: cartoons, picture puzzles, and so forth. Duchamp's "trick" consisted of a total identification with ordinary things, ideally without any manipulation whatsoever, as a means of startling people into discovering the esthetics of industrial mass production. Even so, he often had to resort to tiny irritations of meaning through the use of titles or minimal modifications to aid the viewer in perceiving his idea of the pure ready-made. It took close to fifty years for Duchamp's methods to become firmly established, practiced, and accepted in the 1960s as a means of artistic production and reception. When Wegman plays with pictorial ideas, he can and must assume familiarity with this method. But, although he plays with the ambivalence of the status between art and non-art, that is, with the appearance of banality, there must be more to it than that. Some works are indeed blatantly banal and senseless, for instance PERCENTAGE PROBLEM (c. 1973; page 151), where Wegman adds the population of Springfield (303,960) to that of Westfield (33,050) and observes that 4 percent of the total (337,010) amounts to 134,804. The two populations are represented in geographical outline in inverse proportion to their size. This work is about as absurdly informative as statistics generally are. Wegman's understanding of art cannot be that banal and trivial. We can, indeed must, assume some underlying sense to it in our attempt to decipher his work. But where and how do we discover it?

Just as Duchamp made fun in his day of elements of the serious avant-garde by applying them to unpretentious subjects, Wegman avails himself of wit to play with the serious pose of those contemporaries who adopt the tautological and art-immanent approach of Conceptual Art and Minimal Art in order to disavow all ordinary subject matter and even all ethical implications. The reductionism of art is ridiculed and simultaneously deployed as method in genuinely funny pictorial forms, typical of humor and satire. In the drawing described above, outlines of states and continents, embellished with often absurd mathematical calculations, make direct, cynical reference to popular Earth Art conceits and other conceptual games.

When Wegman zeros in on the missionary earnestness of his ascetic avant-garde peers, he uses the same devices; he shifts the associative field of his subject matter to more quotidian, prosaic regions where conceptual games become so trivial and banal that they suspend the claim to art in the sense of the traditional drawing, much like Duchamp's ready-mades did half a century ago. But Wegman prevents his artistic acts from being thoroughly misunderstood or overlooked by

adopting the compositional means and working methods of the avant-garde itself: the use of photography in the art context, the preference for sequences and series, the association of images with written signs and captions, the staging of actions and installations in rooms, to mention but a few. In like fashion, the avant-garde adopted and claimed artistic status for the medium of the videotape.

Wegman's drawing is a different affair altogether. The principle pictorial form of Conceptual Art was pure text in combination with photography; only very rarely did traditional techniques, such as the media of painting and drawing, come into play. This applies above all to English and American Conceptual Art. It is astonishing that some artists in continental Europe did try to advance a less dogmatic and therefore less verbal form of Conceptual Art. I am thinking, for instance, of exponents of Arte Povera—Giovanni Anselmo, Giulio Paolini, Luciano Fabro—or individual artists like Sigmar Polke in Germany or Markus Raetz and Aldo Walker in Switzerland, who frequently deployed the traditional form of the drawing for highly conceptual purposes, although virtually no one views their output as "conceptual." But with the exception perhaps of Polke and Raetz, these artists generally do not draw on the trivial forms of the drawing in popular art, typified by cartoons, comic strips, or text illustration.

William Wegman's first such illustrative drawings of 1974 reflect a pseudo-artistic style that prevails especially in English-language media and is much more popular in the United States or England than in continental Europe. A typical, early example is the cartoon drawing, 5¢ MORE (1975; page 162), which combines words and picture in an explosive display of sarcastic wit. The picture is rendered in the style of the traditional ink drawing, characteristic of work by practiced commercial artists. The contours of the three figures in this dagger scene have been inked in except for a very thin edge, which heightens the black-and-white contrast. Planes of black drawing ink reproduce well and retain their impact even in newspaper reproductions. It is, therefore, not only the narrative content but especially the style of draftsmanship that makes Wegman's picture look so familiar. In fact, the characteristically popular, illustrative style is even more conspicuous in the original drawing without necessarily establishing a conscious connection with the reproduced form of mass printing. Wegman adapts styles of illustration and manipulates their content not only in terms of the tradition of the serious illustration; he also draws on sources like slick magazines for men with their sex cartoons and pornographic illustrations.

In YOU'LL NEVER CHANGE (c. 1976; page 165) Wegman's humorous bent has given way to cynical sarcasm. The drawing may be sending out a message about sex or commenting on the cultural value of his pictorial sources, that is, popular art at its most "primitive." It does not say; but Wegman's references to the topics of sex, beautiful women, the hackneyed themes of the entertainment media and of society in general, are not infrequent. For one thing, they are aligned with the central motif of his work, the transferral of the most banal, least artistically incriminated pictorial material to the domain of art without making noticeable changes. In approach, they are similar to the non-narrative, minimalist drawings that seek out banality to undercut their status as art. Wegman's more minimalist drawings date from 1972; his more popular, illustrative ones from 1973/74. In the mid-eighties, he moved on from "graphic" drawings to more "painterly" ones and seamlessly on

to the traditional easel paintings that are currently his main concern.

Color first made its appearance when Wegman began focusing with greater intensity on popular illustration. Color had previously served more emblematic ends, especially in works of a conceptual nature, like WOOD (1975), where a green swath of color above a tree provides the backdrop for the negative lettering of the word "wood." The drawings resembling picture stories and cartoons are even more colorful. What is most striking in works like FUN (1982; page 140) or FEMALE RELATIONSHIP (1980; page 169) is the eroticism that often insinuates itself into the subject matter. Not until then did the growing need for a more colorful world prevail through an extension, one might almost call it a transcendence, of the drawing.

It is of note that Wegman began enjoying the use of color only through slow and intense involvement with it. Not until he took up painting did he discover the potential of color, which he had once categorically rejected. HOPE (1985; page 185) is captioned with a commentary that refers to the picture's execution: "I CHOSE RED FOR THE GIRLS' HAIR AND BACON RIND TO ACCENT THE PICTURE. . . . I THINK IT MAKES A NICE, SIMPLE PICTURE AND I AM MORE THAN HAPPY WITH IT. WILLIAM WEGMAN." Since pictures like THE BLESSING OF THE FIELD (1986; page 194), he has exploited the potential of oil paint to superimpose thin layers of color; to let several pictorial planes flow into each other in a colorful, atmospheric pictorial space. Out of clearly isolated pictorial elements and objects he artificially creates a single fictional pictorial space. One is reminded of the photographic technique of making double, triple, or multiple exposures. This approach to painting, which originated in the colored drawing, did not exercise much of a retroactive influence on Wegman as a draftsman; instead he devoted himself increasingly to the vehicle of the traditional easel painting. It has acquired a dominance in his recent work on a par with his Polaroid pictures of Fay Ray.

Wegman has not given up drawing altogether but now uses it again, as he once did, for the purpose of developing ideas or playing a drier but stimulating intellectual picture game. Encoded picture puzzles are likely to crop up as ironic commentaries on art, as in SCULPTURE (1983; page 177), a drawing of art-stelae furnishings. The drawing has developed in step with Wegman's explorations of other media, from black-and-white photography, whose seemingly banal picture puzzles it assimilated, to the integration of popular cartoon art, which then became the stepping-stone to the world of color in paintings where he reveals himself to the viewer more palpably than ever before. The drafted oeuvre is the core, the spiral axis around which Wegman's entire artistic output revolves. Sometimes the axis is turned and affected by movement from without; sometimes it is a self-generated, centrifugal movement. But have we, in a deeper sense, come closer to Wegman's art?

I do not see Wegman as the comic, the joker he is always made out to be. As always, appearances deceive. Look, finally, at the drawing OWN YOUR OWN (c. 1982; page 172), a simple word/picture game in which sketches replace the corresponding words in a text. A child's rebus? That's the question. The crossword puzzle in the German weekly, DIE ZEIT, runs in a column titled, "Um die Ecke gedacht" (literally: "Thinking around Corners"). It is known for its deceptively

simple clues with tricky solutions that are impossible to find by taking the obvious and logically shortest distance between two points. Wegman's indirect route is the constantly shifting art context itself. I must ask you to solve the riddle by turning (not cutting!) your own corners as best you can. In the other mediums, in self-representations through his mirrors, Man Ray or Fay Ray, we can gaze at the two tiny dots of the eyes and at least guess at the infinite dimensions of that tragic being, man, dressed as the fool.

FLASHLIGHT. c. 1974. Ink, watercolor on paper, $8^1/_2 \times 11''$. Courtesy Holly Solomon Gallery, New York

DRYING. 1975. Pencil, watercolor on paper, $8^1/_2 \times 11''$. Courtesy Holly Solomon Gallery, New York

PERFECT HAIR, PERFECT TEETH. c. 1975. Pencil, watercolor on paper, $8^1/_2 \times 11''$. Collection the Artist

COMPLIMENTARY AND ADJACENT FIGURES. c. 1978–79. Watercolor on paper, $8^1/_2 \times 11''$. Courtesy Holly Solomon Gallery, New York

FUN. 1982. Ink on paper, 10⅝ × 13½". Courtesy Holly Solomon Gallery, New York

SICK. 1982. Watercolor on paper, 11 × 14". Collection the Artist

CLEOPATRA. 1981. Ink, gouache on paper, 12 × 9″. Collection the Artist

DIET ÷ FISH

BREAKFAST

2 slices cod

LUNCH

2 shrimp bits

DINNER cod bits +
 shrimp slices

MENU. 1983. Ink on paper, 12 × 9″. Collection the Artist

*. 1983. Watercolor on paper, 14×11″. Courtesy Holly Solomon Gallery, New York

WANT TO GO OUT TO DINNER — THEN A MOVIE

WANT TO GO OUT FOR DINNER? 1983. Ink and watercolor on paper, 9 × 12″. Collection the Artist

TWO BIRDS, ONE WORM. 1989. Watercolor on paper, 9 × 12″. Collection the Artist

4 HAIRPINS/4 PAPER CLIPS. 1973. Pencil on paper, $8^{1}/_{2} \times 11''$. Courtesy Holly Solomon Gallery, New York

16 E'S 16 L'S. 1973. Ink on paper, $11 \times 8^{1}/_{2}''$. Courtesy Holly Solomon Gallery, New York

BROKEN EYE GLASSES. 1973. Pencil on paper, $8^{1}/_{2} \times 11''$. Courtesy Holly Solomon Gallery, New York

DESK/HOUSE. 1973. Pencil on paper, $8^{1}/_{2} \times 11''$. Courtesy Holly Solomon Gallery, New York

FACADE OF AMIENS CATHEDRAL. 1973. Pencil on paper, $8^{1}/_{2} \times 11''$. Courtesy Holly Solomon Gallery, New York

HOUSE AND BIT. c. 1975. Pencil on paper, $8^{1}/_{2} \times 11''$. Courtesy Holly Solomon Gallery, New York

UNITED FAITHS. c. 1973. Pencil on paper, $11 \times 8^{1}/_{2}''$. Courtesy Holly Solomon Gallery, New York

UNIVERSITY ARCHITECTURE. 1973. Pencil on paper, 8½ × 10¾″. Courtesy Holly Solomon Gallery, New York

STUBBORN AS A MULE FAT AS A PIG. C. 1973. Pencil on paper, 8½ × 11″. Courtesy Holly Solomon Gallery, New York

VIDEO TAPE REELS. c. 1973. Pencil on paper, 8¹/₂ × 11″. Courtesy Holly Solomon Gallery, New York

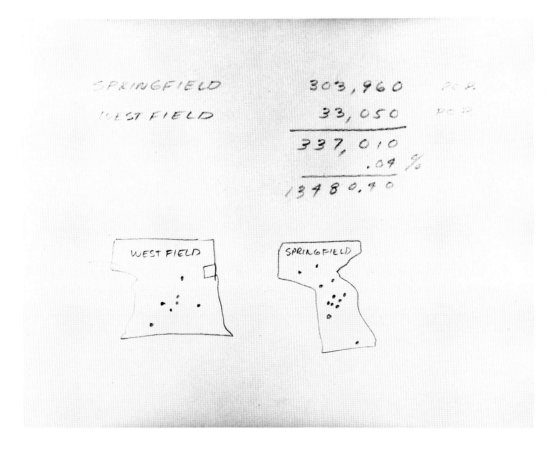

PERCENTAGE PROBLEM. c. 1973. Pencil on paper, 8¹/₂ × 11″. Courtesy Holly Solomon Gallery, New York

THE NEW OPERA HOUSE. 1973. Pencil on paper, 9 × 12″. Collection Marsha and Stephen Berini, California

green lucite

neighbors ball bounces over
house instead of through ...

NEIGHBOR'S BALL BOUNCES OVER HOUSE. c. 1973. Pencil on paper, $8^1/_2 \times 11''$. Courtesy Holly Solomon Gallery, New York

TABLE SETTING. 1973. Pencil on paper, $8^{1}/_{2} \times 11''$. Courtesy Holly Solomon Gallery, New York

SHAPE OF THE DESK DOESN'T MATTER; KIDS STILL GET BORED. c. 1973. Pencil on paper, $8^{1}/_{2} \times 11''$.
Collection Marsha and Stephen Berini, California

BROKEN TELEPHONE CABLE. c. 1973. Pencil on paper, $8^{1}/_{2} \times 11''$. Collection Marsha and Stephen Berini, California

KIND OF DIVE. 1973. Pencil on paper, $8^{1}/_{2} \times 11''$. Courtesy Holly Solomon Gallery, New York

BUMP IN THE ROAD. c. 1973. Pencil on paper, $8^{1}/_{2} \times 11''$. Courtesy Holly Solomon Gallery, New York

DANGEROUS/SAFER. 1974. Pencil on paper, 11 × 14″. Courtesy Holly Solomon Gallery, New York

SINGING BOYS AFTER DELLA ROBBIA. 1974. Ink on paper, 11 × 14″. Courtesy Holly Solomon Gallery, New York

DOUBLED PROFILE. c. 1974. Pencil on paper, 8¹/₂ × 11″. Courtesy Holly Solomon Gallery, New York

OH BOY, IT'S A GIRL. c. 1974–75. Ink on paper, $5^3/4 \times 15''$. Courtesy Holly Solomon Gallery, New York

9/7. c. 1975. Pencil on paper, $8^1/2 \times 11''$. Courtesy Holly Solomon Gallery, New York

CO—MB. c. 1975. Ink on paper, each 11 × 8¹⁄₂″. Courtesy Holly Solomon Gallery, New York

A HOLIDAY. c. 1975–76. Ink on paper, 8¹/₂ × 11″. Courtesy Holly Solomon Gallery, New York

5¢ MORE. 1975. Ink on paper, 8¹/₂ × 11″. Courtesy Holly Solomon Gallery, New York

make ⅛″ incision
connecting fang marks
suck out venom
and spit it out
in container
at hips

MAKE ⅛″ INCISION. c. 1975. Pencil on paper, 8½ × 11″. Courtesy Holly Solomon Gallery, New York

PRODUCER/ACTRESS. c. 1975. Pencil on paper, 8½ × 11″. Courtesy Holly Solomon Gallery, New York

HEY, LOOK WHAT I FOUND. c. 1976. Watercolor and pastel on paper, 8¹/₂ × 11″. Courtesy Holly Solomon Gallery, New York

YOU'LL NEVER CHANGE. c. 1976. Pencil, watercolor on paper, 8$\frac{1}{2}$ × 11″. Courtesy Holly Solomon Gallery, New York

FRANCE: PAST & PRESENT. 1976. Pencil, ink, watercolor on paper, 6³/₄ × 8¹/₄″. Courtesy Holly Solomon Gallery, New York

CONNECTICUT/ITALY. 1975. Pencil, watercolor on paper, $8^{1}/_{2} \times 11''$. Courtesy Holly Solomon Gallery, New York

DRILL BITS. c. 1978. Ink on paper, 12 × 9″. Courtesy Holly Solomon Gallery, New York

CURVO-ANGULAR PROFILES. c. 1978. Ink on paper, 8¹/₂ × 11″. Courtesy Holly Solomon Gallery, New York

FEMALE RELATIONSHIP. 1980. Ink on paper, 11 × 14″. Courtesy Holly Solomon Gallery, New York

RELIGIOUS GOODS. c. 1980. Ink, watercolor on paper, 9 × 12″. Collection Marsha and Stephen Berini, California

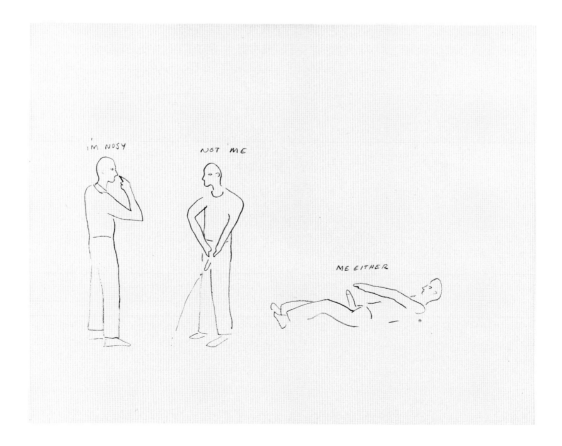

NOSY GUYS. 1982. Ink on paper, 11 × 14″. Courtesy Holly Solomon Gallery, New York

PORTRAIT OF A YOUNG GIRL. 1982. Pencil on paper, 12 × 9″. Courtesy Holly Solomon Gallery, New York

OWN YOUR OWN. c. 1982. Ink on paper, 12 × 9". Courtesy Holly Solomon Gallery, New York

RED/BOLDFACE. c. 1982. Marker, pencil on paper, $8^{1}/_{2} \times 11''$. Courtesy Holly Solomon Gallery, New York

AN OPEN LETTER:

I LOVE YOU WITH ALL MY BEING. I WANT YOU WITH A PASSION AXL WHICH KNOWS NO BOUNDARIES. DO YOU LOVE ME AS I LOVE YOU?

Love,
xx Bill oo
Wegman

AN OPEN LETTER. 1982. Ink on paper, 9×11″. Courtesy Holly Solomon Gallery, New York

Oh give me
a home where
the Buffalo
room and
the dear* and
the antelope
play. More
vino please.
Where seldom
is heard a
discouraging

DEER

DEAR DEER, 1982. Ink on paper, 22 × 14″. Courtesy Holly Solomon Gallery, New York

TORSO & HEAD. c. 1983. Ink, watercolor on paper, $12^1/_2 \times 9^1/_2''$. Collection Marsha and Stephen Berini, California

SCULPTURE. 1983. Ink on paper, 11 × 14″. Courtesy Holly Solomon Gallery, New York

WORLD OF PHOTOGRAPHY: ZONE SYSTEM. 1985. Ink on paper, 14 × 17″. Courtesy Holly Solomon Gallery, New York

WORLD OF PHOTOGRAPHY: LIGHTING. 1985. Ink on paper, 17 × 14″. Courtesy Holly Solomon Gallery, New York

OL BLUE NOSE. 1986. Watercolor on paper, 10 × 10″. Collection the Artist

PETER SCHJELDAHL

Paintings:
The New Wegman

When first widely shown in the 1970s, William Wegman's photographs and videotapes of himself and his dog Man Ray delivered a sensationally dire message about the social fate of art. They demonstrated that a modern ideal of art as a refuge for free spiritual play, in a culture of mechanically entertaining mass forms, had succeeded—disastrously. The truth streamed from the doleful countenance of a Weimaraner. The truth was that creative freedom had become secure and supreme within a playpen whose bars were repressive tolerance. Freedom had become obedience: pet tricks. Wegman emerged as an artist of monumental drollery and bottomless sadness. Within the borders of the photograph and the box of the television set, liberty of thought and fantasy was shown to be sacrosanct, as if established in some inviolable Constitution by Founding Fathers long ago. All the revolutions came down to this: a man and his dog, a man and a Man. The man told jokes, because when you don't know to whom you are talking, or why, it is prudent to be charming. Maybe the attending Strangers will laugh, and that will be a temporary deliverance. At least, They will see that you are harmless. Meanwhile, the dog focused all its animal resources and neurotic intelligence in agonized efforts to anticipate the man's wish. Together within art's austere frame, as upon a distant planet colonized by Elders only dimly remembered, the dog and the man labored to ingratiate.

Founding Fathers, Strangers, Elders: ghosts of hope and purpose that created our age and didn't live to see it—or saw it and perished of the sight, or were supposed to be its citizens but failed to appear—passed among us in the exhibition spaces where we viewed Wegman's early work. Those were haunted spaces of a very free, bored, wandering time. The humor and melancholy of Wegman's photography and video were as clear as spring water, with no stain of pretension. His honesty pointed to the future. In his poetic of sweet coldness and sweet exhaustion, something authentic could begin anew. He became an important influence on the generation of artists who made a great, angry, sexually charged efflorescence at the start of the 1980s. You can feel, if not see, his influence in the decisive work of Jonathan Borofsky, Cindy Sherman, David Salle, and Eric Fischl, among many others. That influence, shared with such other forerunners of the present as Bruce Nauman and Edward Ruscha, pertains to life entirely mediated by the culturally designated role of the artist, chained to the frightening freedom of the esthetic. To be an artist, in our age, is to be radically alone within the playpen of the frame. It is a strange aloneness, because thronged with cultural memory and received images and the legions of the self: animal, child, adolescent, man/woman, professional, shaman. The role is a bliss and an ordeal, guaranteed by a social license so extraordinarily arbitrary that it might be revoked at any time. Moment to moment, as if tapping out last messages from a sinking ship, the artist produces bulletins about what it means RIGHT NOW, and will always have meant ONCE, to be alive.

Wegman survived the passing of the '70s, and the death of the dog Man Ray, with difficulty. While always revered among artists and rarely faltering in the quality of his work, he has a temperament which, like a camel, is accustomed to going long distances without nourishment. He seemed a thin man at the feast of the '80s. Art's situation had changed. Slowly, befitting a spirit doomed to integrity, Wegman changed with it, becoming a painter in 1985—at about the time when the era's massive wave of new painting, throughout the United States and Europe, broke and began to ebb. His initial paintings, the first he

had made since he was an art student in 1966, looked aesthetically frail as well as belated. They extrapolated, with color and texture, the infallibly witty drawings he had never ceased to make, and they couldn't help but be amusing. But I remember being dubious about them. I could not immediately recognize that Wegman's art had entered a new phase, which cracked the frame of his previous isolation. In a way, he was humbly accepting his own influence, a new, sociable Wegman taking advantage of permissions granted by the old, hermetic Wegman. Thus commenced a lovely, increasingly powerful blossoming of communal subject matter in his work. The subject matter is the whole, wide world as it lodges in the imaginations of the children that none of us ever cease to be. Wegman has been reborn as a sort of American, cybernetic-age, Protestant Chagall, whose lost and constantly recovered Vitebsk is the planet Earth.

I had a good time comparing memories of our respective childhoods with Wegman, while preparing to write this essay. He is the only artist I know who, like me, was raised a religious Lutheran (and who, like me, flipped from fervent belief into atheism at the onset of sexuality). Lutheranism is a pitilessly self-conscious faith. "Every man his own priest," Martin Luther enjoined—meaning that a state of grace with God, which alone promises salvation, is knowable strictly in each individual's secret heart. Lifelong anxiety is assured. Any experience of being "in the wrong," no matter how trivial its circumstance, is apt to shake the very foundations of self-confidence. There is a compensatory gravitation, in fantasy, to remembered experiences of grace, when one had a sense of virtuous union with divine purpose. (I am speaking of a psychological condition now, having nothing to do with actual belief). Such experiences are purest and most intense in early adolescence, when newly mature consciousness still has access to the boundless credulousness of childhood. I was acutely moved when Wegman showed me certain sources of the images in his recent painting: banal, youth-oriented encyclopedias and geography books of the 1950s, featuring a peculiar brand of luridly enhanced color photography of exotic lands and people. When he was young, Wegman told me, he fell asleep while poring over such books. And I remembered, suddenly, the warmth of my own adolescent bed when just those sorts of dry and garish, printed images blurred into dreams.

This is art, whose criterion is specific truth. It does not matter whose truth—whose cultural and personal Byzantium—is revealed, only that the terms of the revelation be clear and responsible. Painting is the probity of Wegman's current art. He observes to an uncommon degree the common sense that painting, like poetry, is a supreme medium of contagious subjectivity: a distillate of someone's mind with which we may willingly drench our own minds, undergoing episodes of benign psychosis, of being "beside ourselves," which enrich and refresh us. Wegman's paintings are grace-machines. Their method is a model of efficiency. "Muzak action painting," he jokingly calls it—alluding to a widespread technology of incessant, insipid background music in public places (Muzak) and to critic Harold Rosenberg's term for an agonistic, existentialist model of Abstract Expressionism (supposedly practiced by Willem de Kooning). Both Muzak and action painting were cultural developments of the 1950s, which also saw a strong influence of modernist abstraction in domestic decoration, Hollywood animated cartoons, greeting-card graphics, Disneyland, and other arenas of "exciting" and "tasteful" popular design. This whole, three-decades-old matrix of high and low artistry stocks the vocabulary of

Wegman's paintings. There is no question of either satire or nostalgia, only of specificity: a historically consistent language of signs that is resonant for the artist with feelings that he chooses to relive and, reliving, to share.

Wegman begins a painting with brushed or sponged washes of acrylic paint in flavorful secondary and tertiary colors—purples and browns, for instance. In itself, before receiving images, this ground is a desultory abstraction pregnant with possibilities, a suggestive terrain with melting zones of warmth and coolness, density and attenuation. Adding images with oil paint and small brushes, Wegman embraces obvious associations of sea and sky, clouds and fog, mountains and chasms. The tone of visualization teeters between classic Chinese landscape and kitsch graphics. The creative procedure is eidetic, teasing imagery from randomness in the familiar surrealist way (of Max Ernst, especially) but without the surrealists' hysterical reverence for the unconscious mind. "Conscious" and "unconscious" are meaningless categories for Wegman, who does not play favorites among the velleities of visual imagination. Fairy castles, little figures on skis, airplanes, Santa Claus, diesel locomotives, sinister grottoes—all his apparitions seem reborn from some prior existence, but their particular histories don't matter. What matters is the insistent, rhythmic pulse of their arrival, the way in which apparently whimsical things take on an air of urgent necessity. Overall, the paintings have a sprightly but bland, Dufy-like look, soothing to the eye; but within their sweet and tepid, matter-of-fact atmospheres, the little images conspire. The little images scheme to drive the viewer crazy.

Juvenile romance and grown-up anguish flicker together in the beautiful SOCIAL STUDIES (1988; page 207), an "encyclopedic" painting. Readings of "sky," "beach," and "sea" are forced upon its vague billows of acrylic wash by notations of clouds, palm trees, pirates, and a galleon. It is about imperialism. The capitalist cathedral of Chicago's Merchandise Mart shimmers above the toy-like ship that must have delivered the buccaneers on the beach, whose leader, in a Napoleonic hat, confronts a native bearing a burden in the same shape as the hat. At the lower right, aboriginal hunters seem to be scampering out of the picture. Drifting above the beach like a shadow of clouds is a gray map of the world's continents. With the delicacy of a daydream, seventeenth-century rapine is conflated with twentieth-century American self-confidence. SOCIAL STUDIES is a boy's reverie of power ever so lightly tinged with inklings of remorse and fear. It is the BATEAU IVRE of a sheltered child. After several minutes of looking at it, I have slipped the moorings of myself and—for a brief, wild moment—have been lost in vertiginous distances.

All of Wegman's paintings do something similar, whipping mild swirls of associations into poetic maelstroms. Some are more intense, and more successful, than others. In Wegman's studio, in company with his new collaborator Fay Ray (who "knows she's a dog, unlike Man Ray"), I was struck by the wide, restlessly experimental range of the paintings, which included a number of instructive failures. When Wegman fails—becoming merely interesting—it is usually in making a picture too contained and objectlike. His successes explode. Their coherence is contradictory and mysterious, like human personality, and one experiences it as an intuition of one's own. This is indeed a redolence of "action painting," the act of painting considered as the invention of a self. Wegman confirms this decade's revaluation of painting, the formerly despised

bourgeois cynosure, as at once the most civilized and the most primordial of mediums. He lures the viewer into the anxiety that Kierkegaard, the Lutheran philosopher, called "the dizziness of freedom." Painting is no neutral convention in his hands. As a New York artist, he recovers it as a talismanic birthright—from the Promethean New York painting of the 1940s and '50s—just as he simultaneously recovers images and tones of his childhood fantasy. In form as well as content, his work finds a subterranean route to the still-living past.

There has been no critical controversy, that I am aware of, occasioned by the appearance of the "new Wegman," but I can readily imagine a revealing debate in which proponents of the "old Wegman" denounce his paintings as betrayals of the institutional triumph of art that he once apostrophized. Such voices would lament a capitulation to the culture of commodities, in which the present market for paintings recalls the seventeenth-century tulip mania of Holland. As an apologist for the "new Wegman," I would answer—and will answer, arguing with myself—that at issue in this art is something more fundamental and drastic than the social constitution of art's audience. At issue is the primitive reality of personal being, which persists darkly in face of attempts either to render it rationally lucid in social-democratic systems or to blend it into the oleaginous feeling-stuff of capitalist mass culture. In shifting his focus from the former matrix to the latter, Wegman simply redeploys a spirit of apparent acceptance which is, in fact, profoundly resistant. Ever passively, but ever stubbornly, he confronts society and culture with evidence of their inadequacy.

Wegman's message is still sensationally dire. Using signs of a decade when Progress was orthodoxy, he makes a gentle, deadly demurral: humanity never changes. In our actual, electric cities no less than in our projected utopias, we are not different from our ancestors who huddled in caves. Stupid cartoons on television and saccharine messages on greeting cards are as chthonic as Lascaux. The stupider the sign, moreover, the more true it is. We may be forever exiled (by a quarter-inch thickness of overcomplicated brain tissue) from the deepest truth, which would be to look a dog in the eye and know that we are equals. But to sink toward that level is to know instinctively, and deliciously, that as we become stupider we become more true. Every man his own priest, his own Virgil, his own Founding Father and Elder and Stranger. In the expensive bourgeois medium, with feather-light whimsy, Wegman enacts a spiralling declension of consciousness. It is like a deep-sea dive that discovers, on the ocean's floor, a populous, glittering metropolis. The ocean is loneliness. It is cold. But in its blurry depth, and only there, live the unkillable, laughing gods.

HOPE. 1985. Oil on canvas, 20¹/₄ × 25¹/₄″. Courtesy Holly Solomon Gallery, New York

MUSEUM OF BEER. 1985. Oil on canvas, 42 × 48″. Courtesy Holly Solomon Gallery, New York

BIRCH BAY. 1985. Oil on canvas with birch bark, 18 × 23″. Courtesy Holly Solomon Gallery, New York

DOCK SCENE. 1985. Oil on canvas, 14 × 19″. Courtesy Holly Solomon Gallery, New York

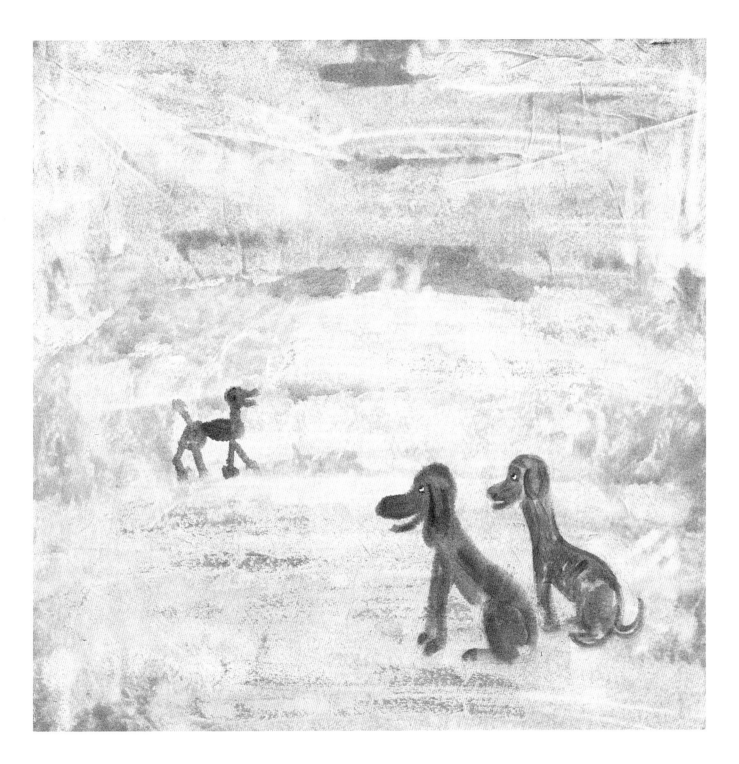

BOY DOGS. 1985. Oil on acrylic ground on canvas, 28 × 28″. Courtesy Holly Solomon Gallery, New York

RADICAL SOFTWARE. 1985. Oil on canvas, 11 × 14″. Collection Ross Bleckner, New York

ON PHOTOGRAPHY. 1986. Oil on acrylic ground on canvas, 24 × 18″. Collection Ed Ruscha, Los Angeles

TRAIN. 1987. Oil on acrylic ground on canvas, 48 × 60″. Collection David Deutsch, New York

ARCHITECTURE. 1987. Oil on acrylic ground on canvas, 74 × 66″. Collection J.C.A. van Esch, Holland

THE BLESSING OF THE FIELD. 1986. Oil on acrylic ground on canvas, 66 × 80″. Collection Holly Solomon, New York

REVOLUTIONARY SKATING. 1987. Oil on acrylic ground on canvas, 30 × 84″.
Collection Mr. and Mrs. William Michaelcheck, New York

PLANE. 1988. Oil on acrylic ground on canvas, 58 × 78″. Collection Chase Manhattan Bank, New York

HARBOR. 1988. Oil on acrylic ground on canvas, 52 × 52″. Collection Mr. and Mrs. Irwin Schloss, New York

ONE DINOSAUR PLAZA. 1988. Oil on acrylic ground on canvas, 40 × 54″. Collection Georges Lavrov, Paris

VOLCANO. 1988. Oil on acrylic ground on canvas, 62 × 54″. Courtesy Holly Solomon Gallery, New York

MIGRATORY ARCHITECTURE. 1988. Oil on acrylic ground on canvas, 54 × 44″. Courtesy Holly Solomon Gallery, New York

CHEMICAL DUMP. 1988. Oil on acrylic ground on canvas, 25 × 29″. Collection Selig Sachs, New York

TRANSPORT, STORAGE, WEIGHING, AND TRANSFER. 1988. Oil on acrylic ground on canvas, 44 × 54″.
Courtesy Holly Solomon Gallery, New York

TWO TOWNS. 1988. Oil on acrylic ground on canvas, $48^{1}/_{2} \times 68^{1}/_{2}''$. Collection the Artist

IRRIGATION. 1988. Oil on acrylic ground on canvas, 68 × 88″. Collection Marsha and Stephen Berini, California

PAST AND FUTURAMA. 1988. Oil on acrylic ground on canvas, 29 × 78″. Courtesy Holly Solomon Gallery, New York

GREEK SET. 1987. Oil on acrylic ground on canvas, $52\,^1/_2 \times 68''$. Collection Holly Solomon, New York

SOCIAL STUDIES. 1988. Oil on acrylic ground on canvas, 56 × 70¹/₄″. Courtesy Holly Solomon Gallery, New York

LANDING. 1989. Oil on acrylic ground on canvas, 56 × 78″. Neue Galerie, Aachen. Collection Ludwig

HOUSE AND VILLAGE. 1989. Oil on acrylic ground on canvas, 32 × 64″. Courtesy Holly Solomon Gallery, New York

TURNER. 1989. Oil on acrylic ground on canvas, 50×60″. Courtesy Holly Solomon Gallery, New York

FIGHTERS. 1989. Oil on acrylic ground on canvas, 56 × 66″. Courtesy Holly Solomon Gallery, New York

COLUMBIA. 1989. Oil on acrylic ground on canvas, 78×60″. Courtesy Holly Solomon Gallery, New York

WESTERN THEATER. 1989. Oil on acrylic ground on canvas, 44 × 54″. Courtesy Holly Solomon Gallery, New York

BIRDS, PLANES, SHIPS. 1989. Oil on acrylic ground on canvas, 44 × 54″. Courtesy Holly Solomon Gallery, New York

TRAVELOGUE. 1989. Oil on acrylic ground on canvas, 44 × 54″. Courtesy Holly Solomon Gallery, New York

International Center of Photography, New
York ("Advertising: Commercial Photog-
raphy by Artists")
Phoenix Art Museum, Arizona ("Altered
Egos")
Queens Museum, New York ("The Real Big
Picture")
Queens Museum, New York ("Television's
Impact on Contemporary Art")

1987

The Alternative Museum, New York
("Poetic Injury: The Surrealist Legacy in
Postmodern Photography"; catalogue)
Center for Fine Arts, Miami, Florida ("Con-
temporary American Figurative
Photography")
Institute of Contemporary Photography,
New York ("Legacy of Light"; catalogue)
Neue Galerie am Johannäum, Graz, Austria
("Steirischer Herbst '87—Animal Art")
Virginia Museum of Fine Arts, Richmond
("Portrait: Faces of the '80s"; catalogue)

1988

The Bruce Museum, Greenwich, Connecti-
cut ("Photographic Truth")
Carpenter Center for the Arts, Harvard Uni-
versity, Cambridge, Massachusetts;
traveled to Haifa Museum, Israel ("Fab-
rications: Staged, Altered, and
Appropriated Photographs"; catalogue)
The High Museum of Art at Georgia Pacific
Center, Atlanta ("First Person Singular:
Self-Portait Photography, 1840-1987")
Queens Museum, New York ("Photography
and Art: Interactions Since 1946")

1989

The Hudson River Museum, Yonkers, New
York ("The Nature of the Beast")
LaForet Art Museum, Tokyo ("Images of
American Pop Culture Today III")
Museum of Modern Art, New York ("Ses-
ame Street: The First Generation")
University Gallery, University of Massachu-
setts, Amherst ("Fantasies, Fables, and
Fabrications"; catalogue)
USSR Artists Union, Moscow ("Painting
Beyond the Death of Painting")
Victoria and Albert Museum, London
("Photography Now")
Whitney Museum of American Art, New

York ("Biennial Exhibition"; catalogue)
Whitney Museum of American Art, New
York ("Image World"; catalogue)
Whitney Museum of American Art—
Downtown Branch, New York ("Identity:
Representations of the Self")
Yokohama Museum of Art, Yokohama,
Japan ("Contemporary Art from New
York")

1990

Museum of Modern Art, New York
("Photography Until Now"; catalogue)

SELECTED BIBLIOGRAPHY

1969

Ralph Pomeroy. "Soft Objects." ARTS
MAGAZINE (May).
Sharp, Willoughby. "Place and Process."
ARTFORUM (November).

1970

Sharp, Willoughby. "Body Works."
AVALANCHE (Fall).
———. "William Wegman." AVALANCHE
(Winter).

1971

Nemser, Cindy. "Subject-Object Body Art."
ARTS MAGAZINE (September/October).
Terbell, Melinda. "Los Angeles." ARTS
MAGAZINE (May).
Wegman, William. "Shocked and Out-
raged." AVALANCHE (Winter).
Winer, Helene. "How Los Angeles Looks
Today." STUDIO INTERNATIONAL
(October).
Winer, Helene. "Introduction," in WILLIAM
WEGMAN: VIDEOTAPES, PHOTOGRAPHIC
WORKS; ARRANGEMENTS. Pomona, Cali-
fornia: Pomona College Art Gallery.

1972

Anderson, Laurie. "Review." ARTNEWS.
Denvir, Bernard. "London Letter." ART IN-
TERNATIONAL (March).

1973

Boice, Bruce. "Review." ARTFORUM
(January).
Kurtz, Bruce. "Video is Being Invented."
ARTS MAGAZINE (December/January).
"Review." ART IN AMERICA (April/May).
Stitelman, Paul. "Review." ARTS MAGAZINE
(December/January).

1974

Wegman, William. "Pathetic Readings,"
AVALANCHE (May).

1975

Lavin, Maude. "Notes on William Weg-
man." ARTFORUM (March).

Sterckx, Pierre. "William Wegman." ART
PRESS 21.

1978

Lewis, Louise. "Shared Humor and Sophis-
tication." ARTWEEK (May).

Lifson, Ben. "Photography Review." THE
VILLAGE VOICE, April 9.

Muchnic, Suzanne. "Art Walk." THE LOS
ANGELES TIMES, December 8.

———. "Conceptualism Spans the Gulf."
THE LOS ANGELES TIMES, May 1.

1979

Frank, Peter. "Review." THE VILLAGE
VOICE, April 9.

"Humor and Participation—Just Off Center
with William Wegman." ADIX (May).

Marzorati, Gerald. "Did I Say Something
Funny?" SOHO WEEKLY NEWS, April 5.

Morgan, Stuart. "Everything You Wanted to
Know about William Wegman but Didn't
Dare Ask." ARNOLFINI REVIEW
(May/June).

Rice, Shelley. "Image Making." SOHO
WEEKLY NEWS, May 24.

Rickey, Carrie. "The More the Merrier."
THE VILLAGE VOICE, October 29.

Stimson, Paul. "William Wegman at Holly
Solomon." ART IN AMERICA (September).

Walker, Ian. "William Wegman." ART
MONTHLY 27.

"William Wegman Altered Photographs."
DOMUS (July).

Zimmer, William. "Five Artists." SOHO
WEEKLY NEWS, November 8.

1980

Armstrong, Richard. "Santa Barbara; Inven-
ted Images: UCSB Art Museum."
ARTFORUM (May).

Grundberg, Andy. "'20 × 24' at Light." ART
IN AMERICA (February).

Johnstone, Mark. "William Wegman: Im-
proved Photographs." ARTWEEK, March
22.

Levine, Les. "Camera Art." ARTES VISU-
ALES (August).

Pohlen, Annelie. "Die Neuen Wilden, Les
Nouveaux Fauves." FLASH ART
(March/April).

Walsh, Mike E. "Photography: Invented Im-
ages." ARTWEEK, May 10.

Wegman, William. "Projects." ARTFORUM
(February).

Whelan, Richard. "Color Polaroid 20 × 24″
Photographs." ARTNEWS (April).

1981

Alinovi, Francesca, and Morra, Claudio.
LA FOTOGRAFIA. ILLUSIONE O
RIVELAZIONE? Bologna, Italy: Società
editrice il Mulino.

Edwards, Owen. "William Wegman Wag
Photographer." POLAROID: CLOSE-UP 2.

Goldstein, Richard. "Artists, an Endangered
Species, Let Them Eat Aesthetics." THE
VILLAGE VOICE, May 13.

Grundberg, Andy. "Mixing Art and Com-
merce." THE NEW YORK TIMES, May 24.

Lawson, Thomas. "Emergent Artists at the
Guggenheim; The Whitney Biennial."
FLASH ART (Summer).

Morgan, Susan. "William Wegman as Told
to Susan Morgan." REALLIFE (Winter).

Perreault, John. "Mideast Pipeline." SOHO
WEEKLY NEWS, January 14.

Ratcliff, Carter. "Tablcau Photography:
From Mayall to Rodan, Its Roots and Its
Reason." PICTURE 18.

Rickey, Carrie. "Curatorial Conceptions:
The Whitney's Latest Sampler."
ARTFORUM (April).

Schjeldahl, Peter. "The Hallelujah Trail."
THE VILLAGE VOICE, March 18.

Smith, Roberta. "Biennial Blues." ART IN
AMERICA (April).

Wieder, Laurance. "William Wegman:
Man's Best Friend." CAMERA ARTS
(July/August).

Zelevansky, Lynn. "Photography at the
Whitney Biennial." FLASH ART
(Summer).

1982

Anderson, Alexandra. "Vignettes: Notes
from the Art World; In Memoriam."
PORTFOLIO (September/October).

Cavaliere, Barbara. "William Wegman: The
David Letterman Show." ARTS MAGAZINE
(May).

Grundberg, Andy. "Photography View:
Photography Has Become a Practice of
Art." THE NEW YORK TIMES, December
26.

Larson, Kay. "A Dog's Life." NEW YORK,
November 29.

Levin, Kim, and Lyons, Lisa. WEGMAN'S
WORLD. Minneapolis: Walker Art Center.

Linker, Kate. "Venice Biennale." ARTFORUM

Murray, Joan. "Man Ray and E.T." ART-
WEEK, October 2.

Ostrow, Joanne. "Polaroid: Not Only In-
stant, But Big!" THE WASHINGTON POST,
March 12.

Smith, Roberta. "Review." THE VILLAGE
VOICE, May 25.

Thornton, Gene. "For William Wegman,
Slapstick is Serious." THE NEW YORK
TIMES, November 7.

Trucco, Terry. "Man Ray's Best Friend."
PORTFOLIO (January/February).

Wegman, William with Wieder, Laurance.
MAN'S BEST FRIEND. New York: Harry N.
Abrams, Inc.

1983

Dupont, Pascal. "Ce Chien est l'homme de
l'année." ACTUEL (December).

"Grabshots." DARKROOM (November).

Honnef, Klaus. "New York Aktuelle."
KUNSTFORUM INTERNATIONAL (May).

Honnef, Klaus. "William Wegman," in
BACK TO THE USA. Lucerne:
Kunstmuseum.

Ianco-Starnels, Josine. "Art News." THE
LOS ANGELES TIMES, September 25.

Lewis, JoAnn. "A Man and His Dog." THE
WASHINGTON POST, July 9.

"Man Ray Portfolio." PARIS REVIEW
(Spring).

Owens, Craig. "William Wegman's Psycho-
analytic Vaudeville." ART IN AMERICA
(March).

Reason, Rex. "William Wegman at Holly
Solomon." FLASH ART (March).

Rickey, Carrie. "Postmodern Pup." THE
VILLAGE VOICE, January 4.

Rogers-Lafferty, Sarah. "Wegman's World."
DIALOGUE (May/June).

Schwartz, Sanford. "The Lovers: MAN'S
BEST FRIEND, Photographs and Drawings
by William Wegman; WEGMAN'S WORLD
by Lisa Lyons and Kim Levin." THE NEW
YORK REVIEW OF BOOKS, August 18.

Stevens, Mark. "From Dada to BowWow."
NEWSWEEK, January 3.

Wise, Kelly. "Intriguing Portraits of the
Self." THE BOSTON GLOBE, June 15.

1984

Apple, Max. "Caring for the Older Dog." THE NEW YORK TIMES MAGAZINE, September 30.

Glueck, Grace. "William Wegman and Izhar Patkin." THE NEW YORK TIMES, March 16.

Hagen, Charles. "William Wegman." ARTFORUM (Summer).

Halpern, Sue M. "In Short: Canine Camera." THE NEW YORK TIMES BOOK REVIEW, September 30.

Larson, Kay. "The Museum of Modern Art Unveils Its Treasures." NEW YORK, May 14.

Levin, Kim. "Revue Review." THE VILLAGE VOICE, March 27.

Reidy, Robin. "William Wegman: Video Artist." IMAGE (October).

Robbins, D. A. "William Wegman's Pop Gun." ARTS MAGAZINE (March).

Wegman, William. EVERYDAY PROBLEMS. New York: Bridgewater Press.

Wegman, William. "Note," in $19.84. Buffalo, New York: C.E.P.A., in conjunction with the Albright-Knox Art Gallery and Hall Walls.

Wilson, Martha. "Books: $19.84." ARTFORUM (December).

1985

Hoberman, J. "Wise Guys." THE VILLAGE VOICE, June 11.

1986

"Album: William Wegman." ARTS (January).

Henry, Gerrit. "William Wegman at Holly Solomon and Daniel Wolf." ARTNEWS (April).

Howell, Sarah. "American Graffiti." THE OBSERVER MAGAZINE, April 6.

Morgan, Susan. "And That's the Way It Is: The Works of Applebroog, Diamond, and Wegman." ARTSCRIBE (June/July).

Muchnic, Suzanne. "Talking Trees, Neon Virtues, Giraffe Nets." THE LOS ANGELES TIMES, November 2.

Raynor, Vivian. "William Wegman: Photographer as Painter." THE NEW YORK TIMES, January 10.

Russell, John. "Neil Winokur." THE NEW YORK TIMES, June 13.

Woodward, Richard B. "The International Center of Photography Comes of Age." ARTNEWS (February).

Wegman, William, and Smith, Michael. "The World of Photography." ARTFORUM (October).

1987

Aletti, Vince. "William Wegman." THE VILLAGE VOICE, March 10.

Hemple, Amy. "William Wegman: The Artist and His Dog." THE NEW YORK TIMES MAGAZINE, November 29.

Indiana, Gary. "Guys and Dogs." THE VILLAGE VOICE, December 22.

Muchnic, Suzanne. "Fay and Ray, via Wegman." THE LOS ANGELES TIMES, December 27.

Squires, Carol. "The Monopoly of Appearances." FLASH ART (February/March).

"The Tail That Wags the Dog." ARTFORUM (September).

1988

Crocket, Tobey. "William Wegman." SPLASH (December).

Freudenheim, Susan. "Under the Singing Eucalyptus Tree . . ." ARTFORUM (April).

Heartner, Eleanor. "William Wegman." ARTNEWS (October).

Hempel, Amy. "Artist with Dog." EASTERN REVIEW (February).

Indiana, Gary. "Doglessness." THE VILLAGE VOICE, May 31.

Levin, Kim. "Choices (Art): William Wegman." THE VILLAGE VOICE, May 17.

Perl, Jed. "All Around the Town." THE NEW CRITERION (September).

Robaard, Joke. "Wie Doet Ons De Tekens Verstaan." KUNSTSCHRIFT (March).

Rosenblum, Robert. THE DOG IN ART. New York: Harry N. Abrams, Inc.

Saltz, Jerry. "Notes on a Painting: A Blessing in Disguise: William Wegman's BLESSING OF THE FIELD, 1986... ARTS MAGAZINE (June).

Smith, Roberta. "From Camera to Paint: New Style for Wegman." THE NEW YORK TIMES, May 13.

Stretch, Bonnie Barret. "Prints and Photographs: A Rich Mixture of Mediums." ARTNEWS (February).

Virshup, Amy. "Picture This." ARTNEWS (March).

Wegman, William. [Drawings]. JOURNAL OF CONTEMPORARY ART (Fall/Winter).

Yau, John. "William Wegman." ARTFORUM (October).

1989

Aupetitallot, Yves; Blistène, Bernard; and Schjeldahl, Peter. WILLIAM WEGMAN. Saint-Etienne, France: Maison de la Culture et de la Communication de Saint-Etienne.

Calnek, Anthony. "New York." CONTEMPORANEA (June).

Gardner, Collin. "Wegman's Worlds." THE LOS ANGELES HERALD EXAMINER, January 6, 1989.

Nathan, Jean. "Puppy Love." THE NEW YORK OBSERVER, November 20.

Straus, Marc. "Facts and Fancy." CONTEMPORANEA (July/August).

Verzotti, Giorgio. "William Wegman: Maison de la Culture, Saint Etienne." FLASH ART (Summer).

Wegman, William. "Insert: William Wegman." PARKETT 21.

Woodward, Richard. "Documenting an Outbreak of Self-Representation." THE NEW YORK TIMES, January 22.

1990

Adams, Brooks. "Wegman Unleashed." ARTNEWS (January).

Kunz, Martin; Sayag, Alain; Schjeldahl, Peter; Wegman, William; Weiermair, Peter. WILLIAM WEGMAN: PAINTINGS, DRAWINGS, PHOTOGRAPHS, VIDEOTAPES, New York: Harry N. Abrams, Inc.

LIST OF WORKS

LENDERS
TO THE
EXHIBITION

Albright-Knox Art Gallery, Buffalo
Allen Memorial Art Museum, Oberlin College
Polly Anthony, New York
BankAmerica Corporation, San Francisco
Richard and Lindy Barnett, Cleveland
Marsha and Stephen Berini, Santa Monica
Ross Bleckner, New York
Judd Burnstein, New York
Chase Manhattan Bank, New York
George H. Dalsheimer, Baltimore
Gerald and Sandra Eskin
Sandy Fellman and Charles Nafman
Bill Frank,
 Place Pigalle Restaurant, Seattle
Paul Frankel, Armonk, New York
Gayle Greenhill, Connecticut
Anita S. Grossman, New York
Daniel Hechter, Paris
William and Ann Hokin
Diane Keaton, New York
Kunsthaus, Zürich
Sherry and Alan Koppel, Chicago
Mr. and Mrs. G. Lavrov
David Leiber, New York
Helen N. Lewis and Marvin B. Meyer,
 Beverly Hills
Loretta Michaelcheck
Gifford Myers/O.Y.O. Studio
Newport Harbor Art Museum,
 Newport Beach, California
Pace/MacGill Gallery, New York
David and Jeanine Smith
Ileana Sonnabend Gallery, New York
Sperone Westwater Gallery, New York
Emily and Jerry Spiegal
Suzanne Tennenbaum, Malibu
Holly Solomon, New York
Holly Solomon Gallery, New York
Doug and Mike Starn, Boston
Laila and Thurston Twigg-Smith
University of Arizona
University Gallery,
 University of Massachusetts at Amherst
Elisabeth and Ealan Wingate